TIN CAN LIFE

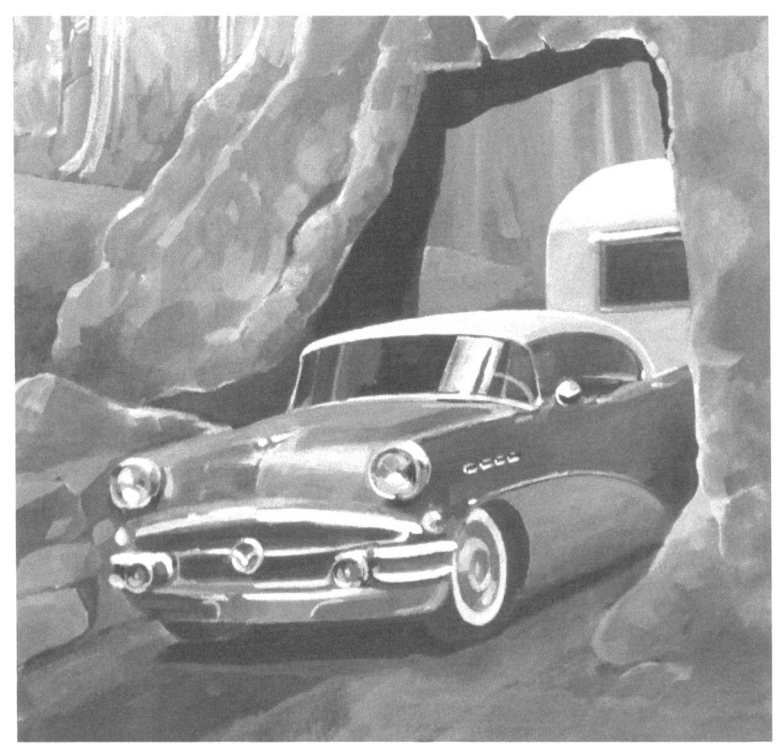

PAINTINGS BY
MICK REASOR

Text and Illustrations Copyright © 2017
by Mick Reasor
All Rights Reserved

The original paintings are gouache on Rives BFK.
The creative process is documented at:

mickreasorsabbatical.blogspot.com

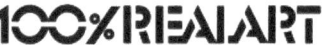

mr.reasor@gmail.com

For Mom who inspired me to become an artist and Dad who had the good sense to try and talk me out of it.

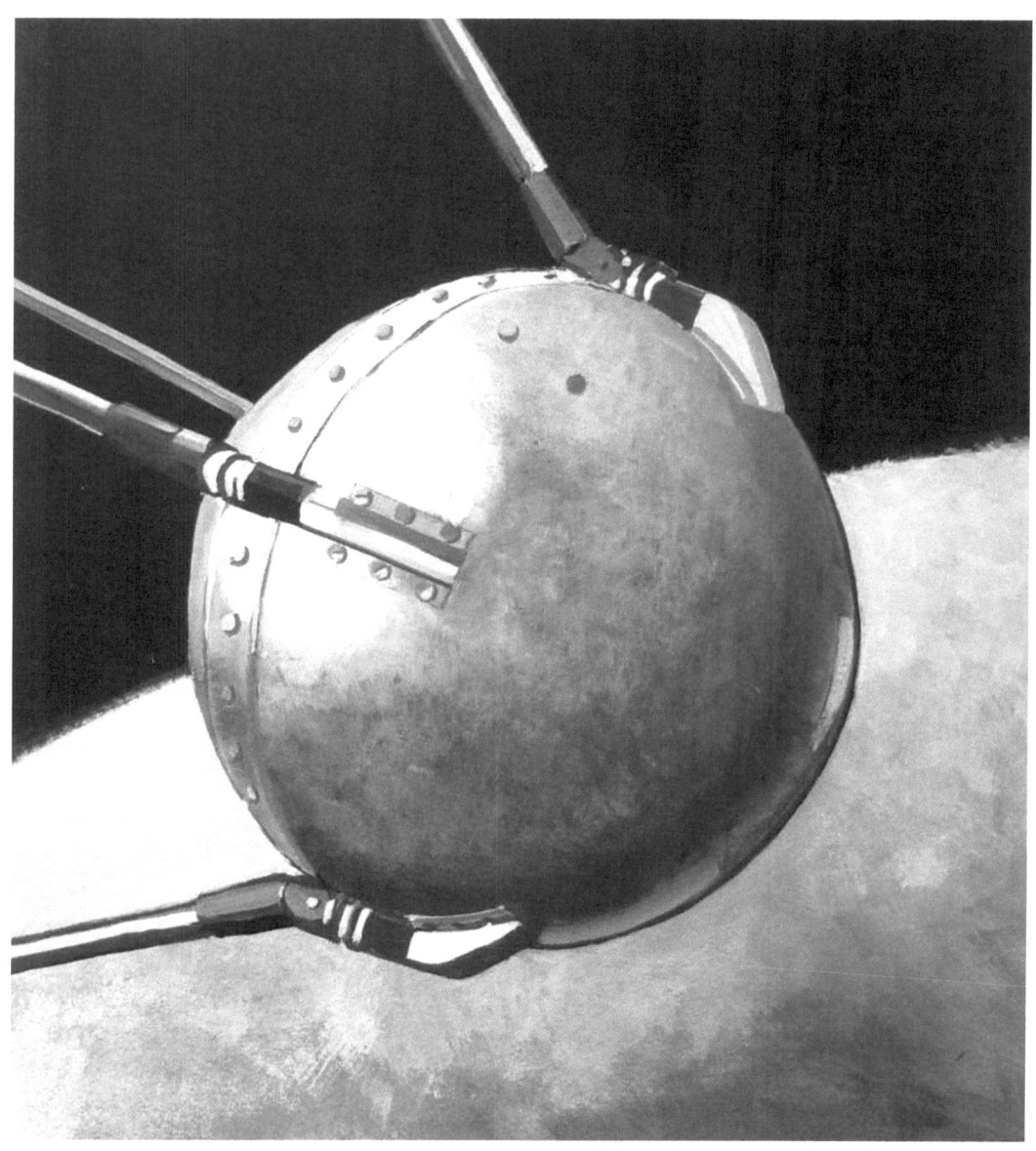

High Tech Tin Can

I was born the son of a warrior (hot and cold) in the year of Sputnik in Biloxi, Mississippi. The first photographic evidence of my existence was produced shortly thereafter at a trailer park near Merced, California.

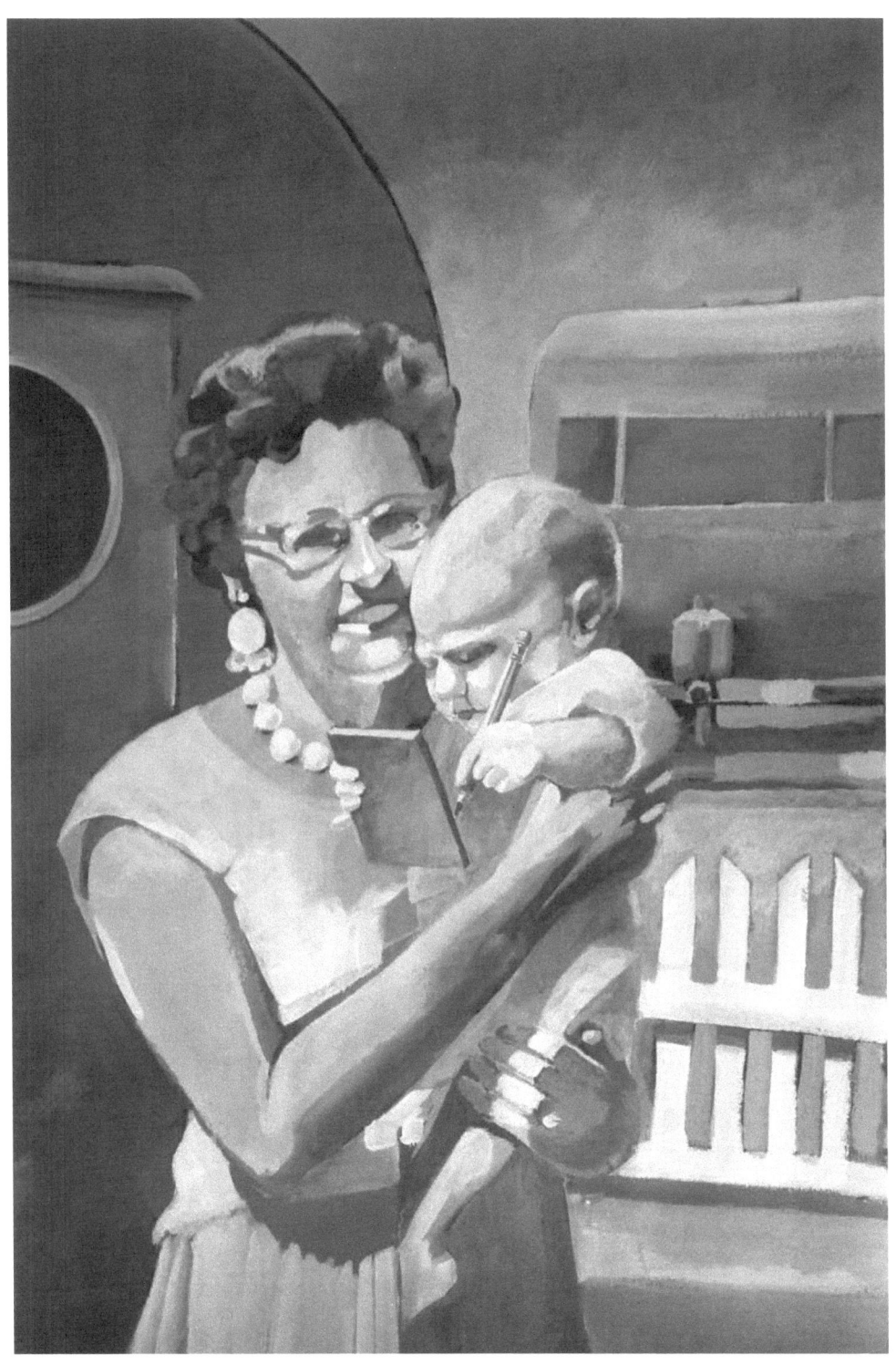

Madonna of the Trailer Park: The Artist as a Very Young Man

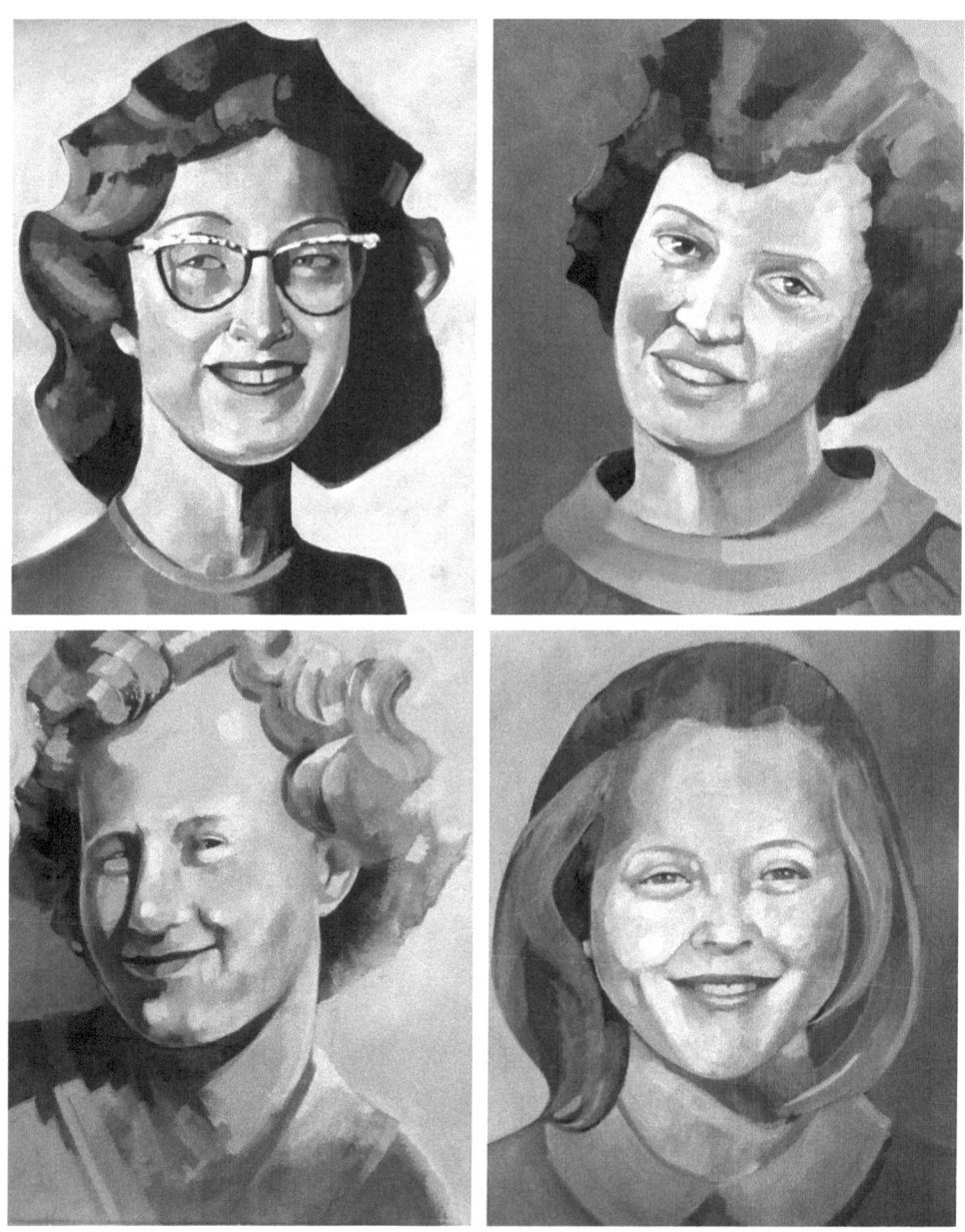

Sisters

With four older sisters and a slightly neurotic dachshund we traveled the country in a 1956 Buick Century. We pulled a sixteen foot canned ham travel trailer that served as our temporary quarters until more permanent housing was acquired.

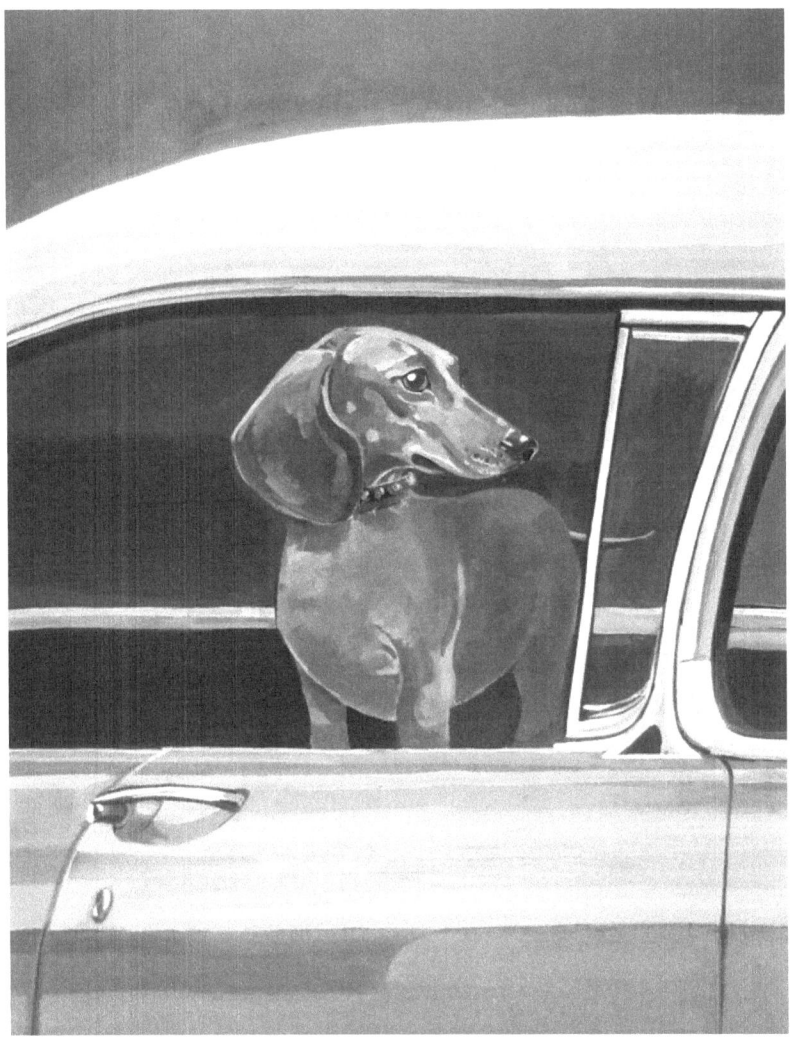

Hey Lady

One of the cool design features of mid-century Buicks was the lack of a B-pillar. When front and back windows were rolled down there was nothing but empty space.

This gave our faithful canine an unobstructed view as she oversaw activities from her perch on the back of the front seat. Here she prevents "bumper boys" from affixing Reptile Gardens stickers to the back of the Buick. Dad didn't care much about the cleanliness of his car but the only sticker allowed was the Air Force decal that drew snappy salutes from the guards at base entrances.

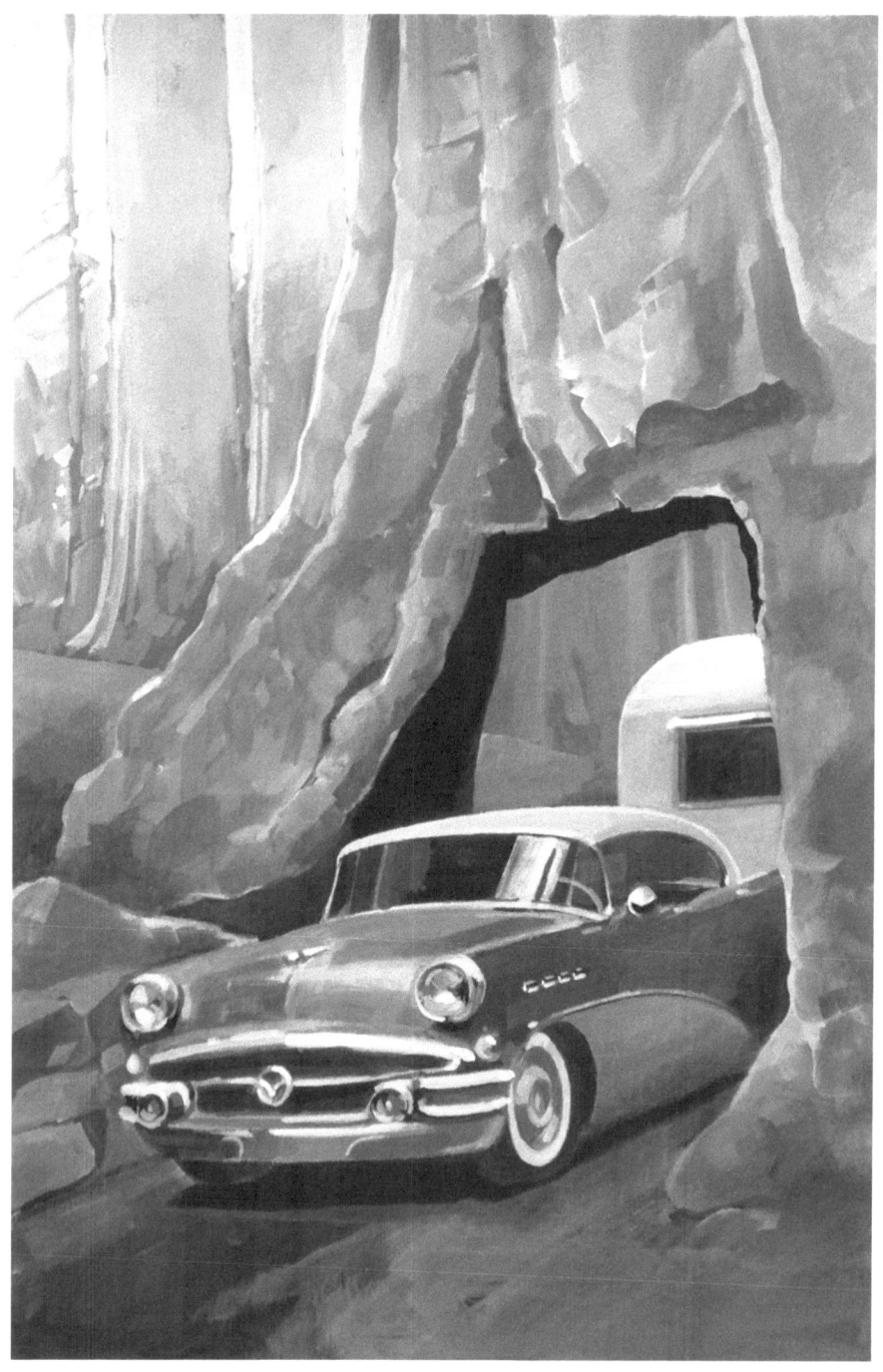

Drive-Thru

Nothing was open-all-night and the only thing you could drive through was a tree.

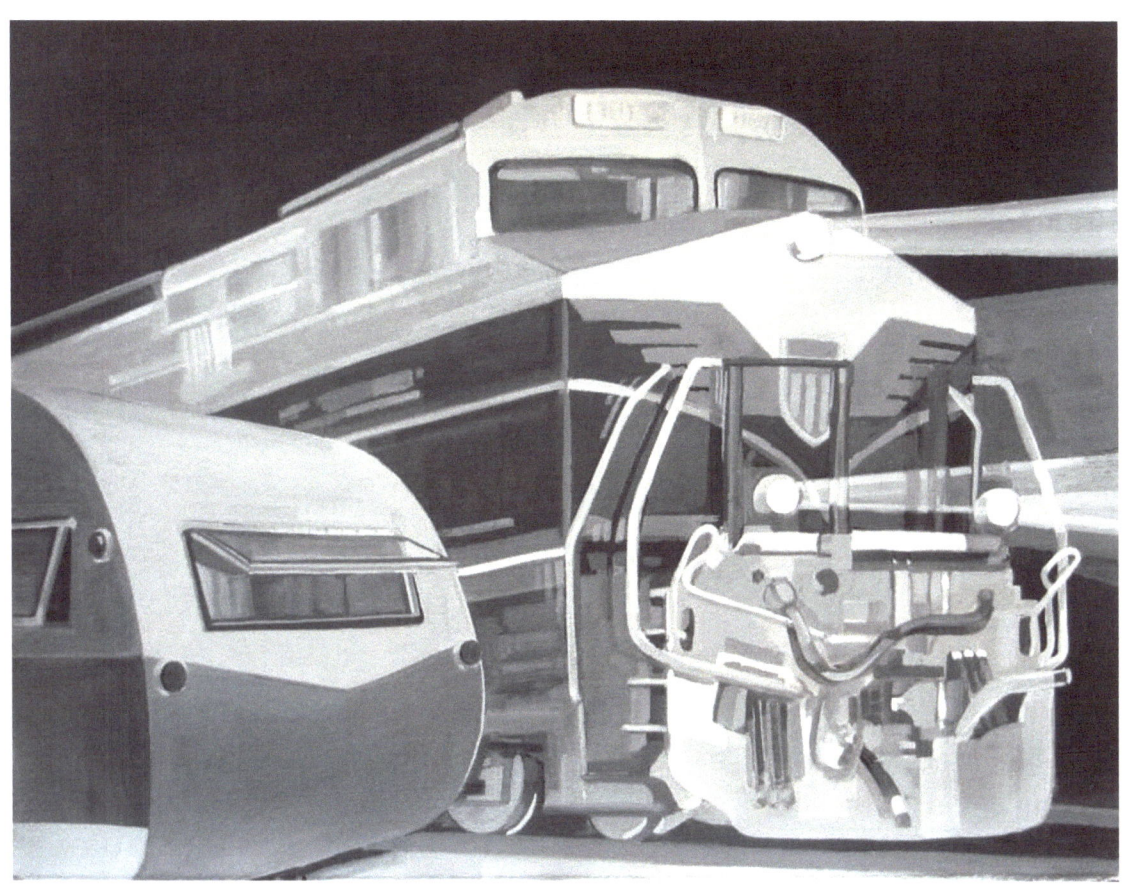

Close Encounters

Dad would drive until he was literally or figuratively out of gas and then pull over behind a filling station where we would sleep until it opened. On one occasion the parking place was perilously close to undetected train tracks. When a freight train blasted by in the wee hours we had a truly rude awakening. Someone (probably Sandi) said it was almost as loud as Kay blowing her nose

Witnesses to a tornado often describe it as sounding like a freight train. You know what else sounds like a freight train? A freight train.

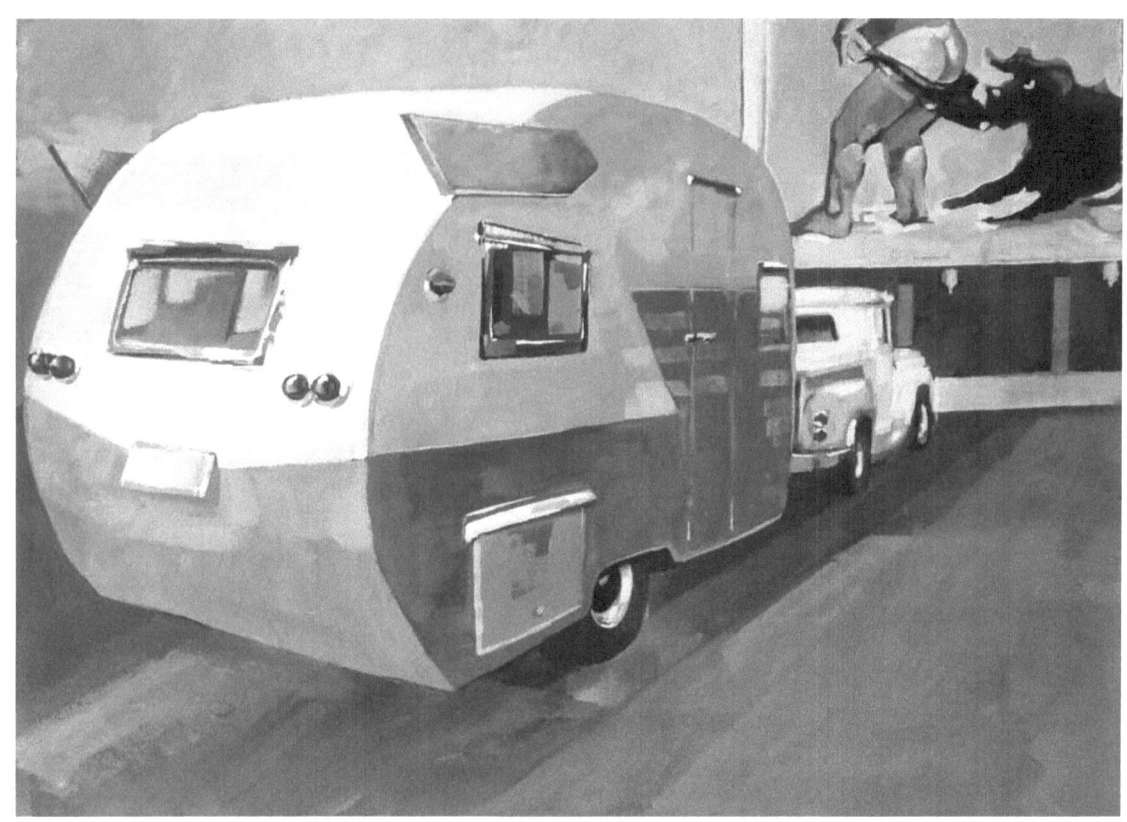

Trailer Envy: Shasta Wings

Although nearly identical in every way to our modest rolling home the Shasta Airflyte sported gleaming aluminum wings that set it apart and above.

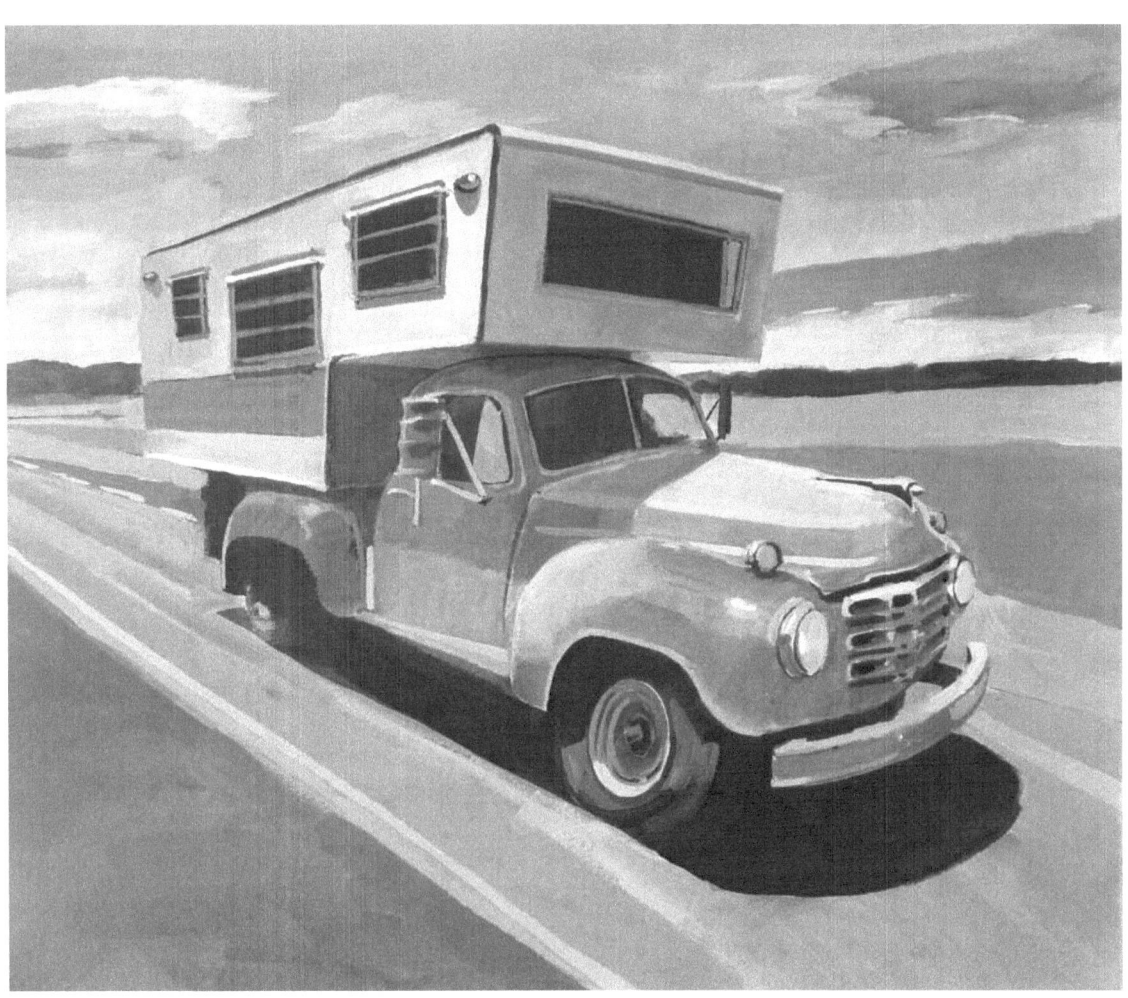

Alternatives: The Camper

Campers were the choice of perverts and pedophiles. That was my opinion based on nothing more than the creepy drifters I saw driving them. Once on a Western highway I saw a little girl part the curtains on the backdoor of a camper and watch us plaintively for several miles. I'm pretty sure she was being kidnapped.

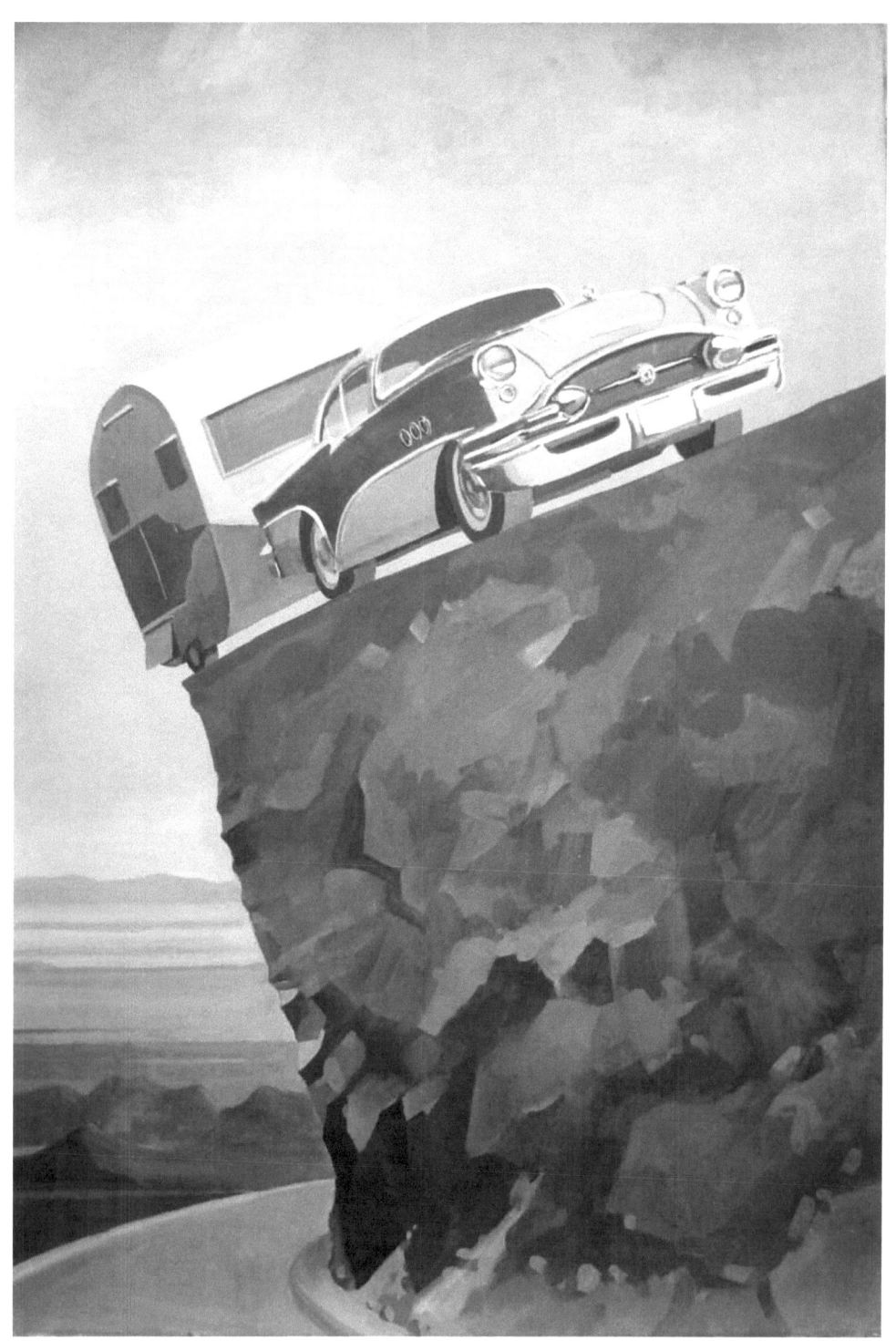

Climb Every Mountain

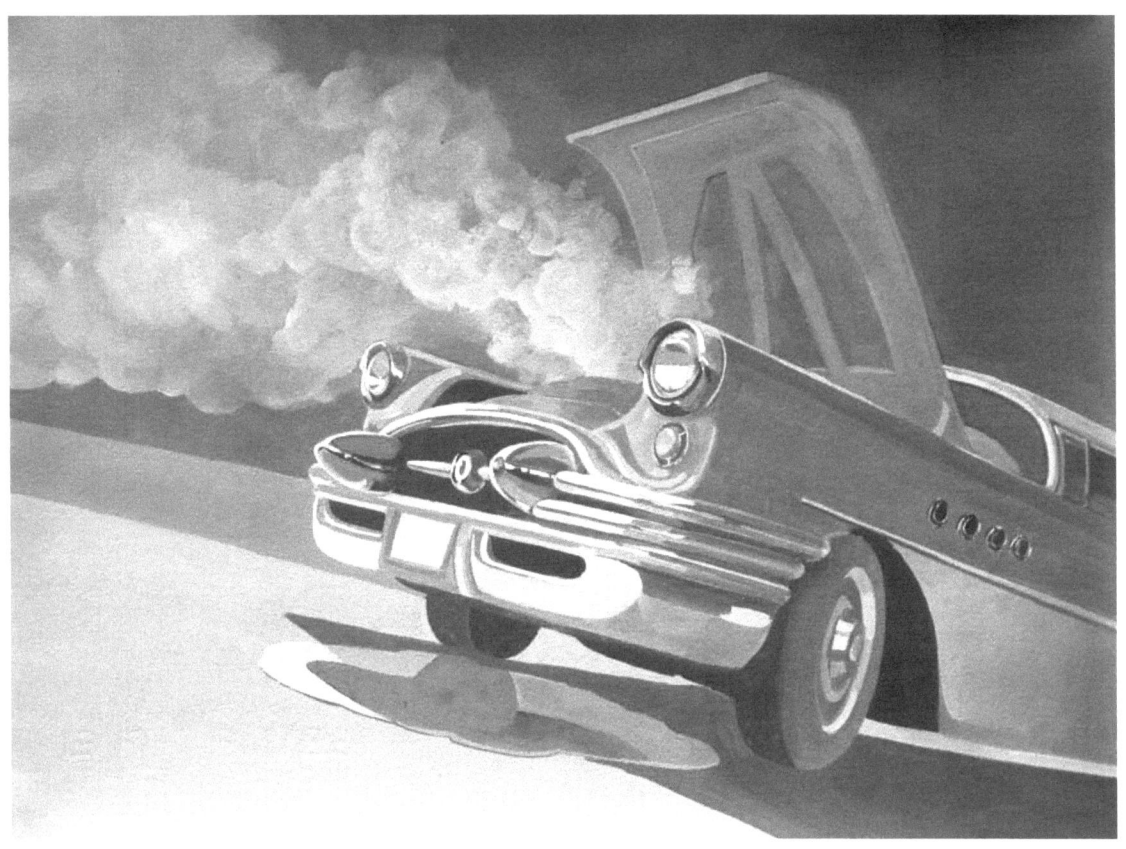

Nice View: Obscured by Clouds

Mom didn't like being on the downhill side of mountain roads. She would use the occasion to tell us how in 1926 she rode with her family in the back of a truck from Indiana to Montana to live with her bachelor Uncle who had gone West to teach school and became a wealthy landowner. He kept his wealth in silver dollars which to this day are believed to be hidden somewhere on the old homestead.

"I was five years old when dad decided, almost overnight, that we were going to Great Falls, or rather to a ranch between Dutton and Power, Montana, to live with my Uncle Grover and work in the wheat harvest. Eight of us...in a Model A Ford truck. The roads weren't paved and I still have an embedded fear of winding mountain roads. They were so narrow with drop-offs that seemed to me to never end."

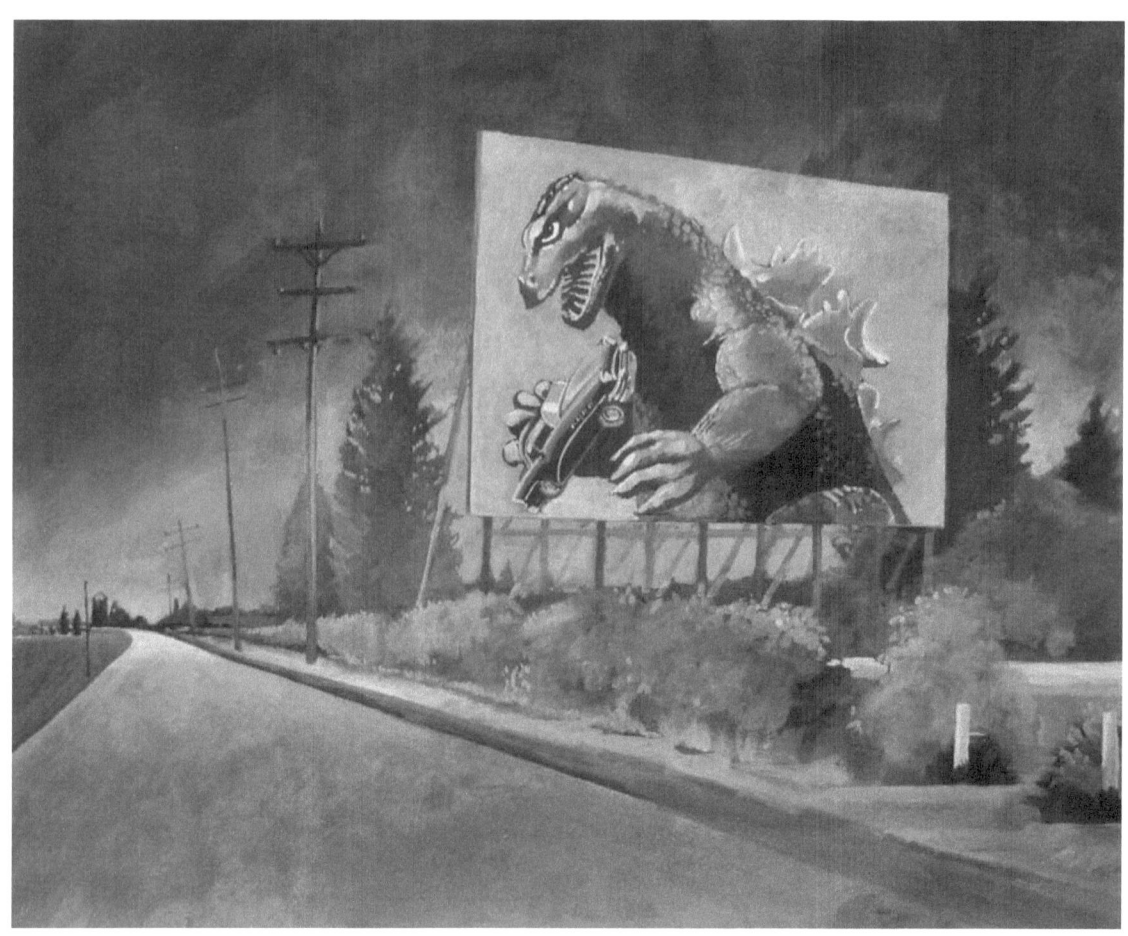

Drive-in

Our entertainment system consisted of an AM radio and a deck of cards. Occasionally we caught a glimpse of a movie as we sped past a drive-in theater. We pronounced the word theater with emphasis on the middle syllable, just like Jethro Bodine.

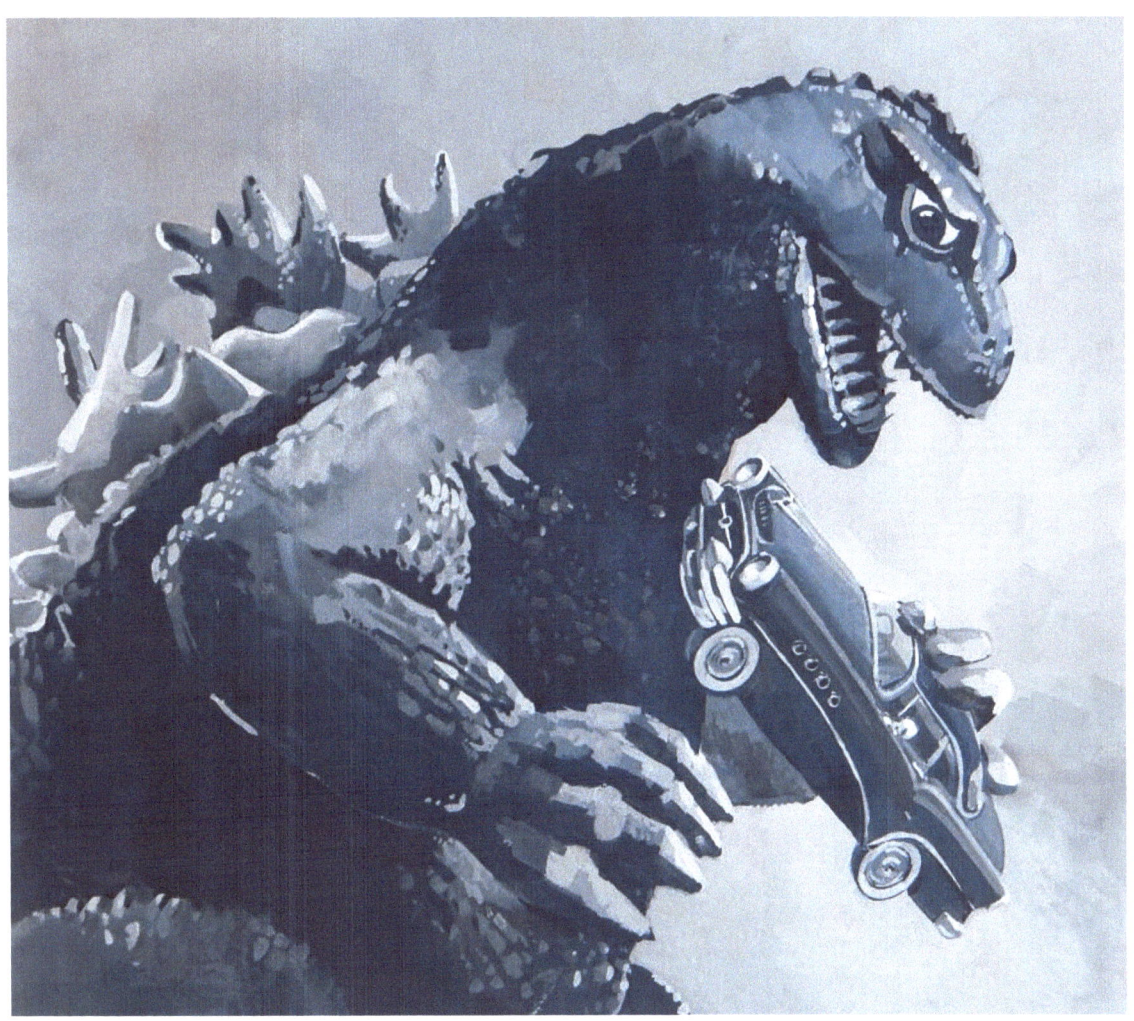

Guy, That's Boss!

As low tech families are required to do, we entertained ourselves. We played Slug Bug and clapping games about stealing cookies from a cookie jar. We counted cars of a specific color (white always won). We sang songs about rotten peanuts, a randy rooster that increased barnyard productivity, and a glad little duck.

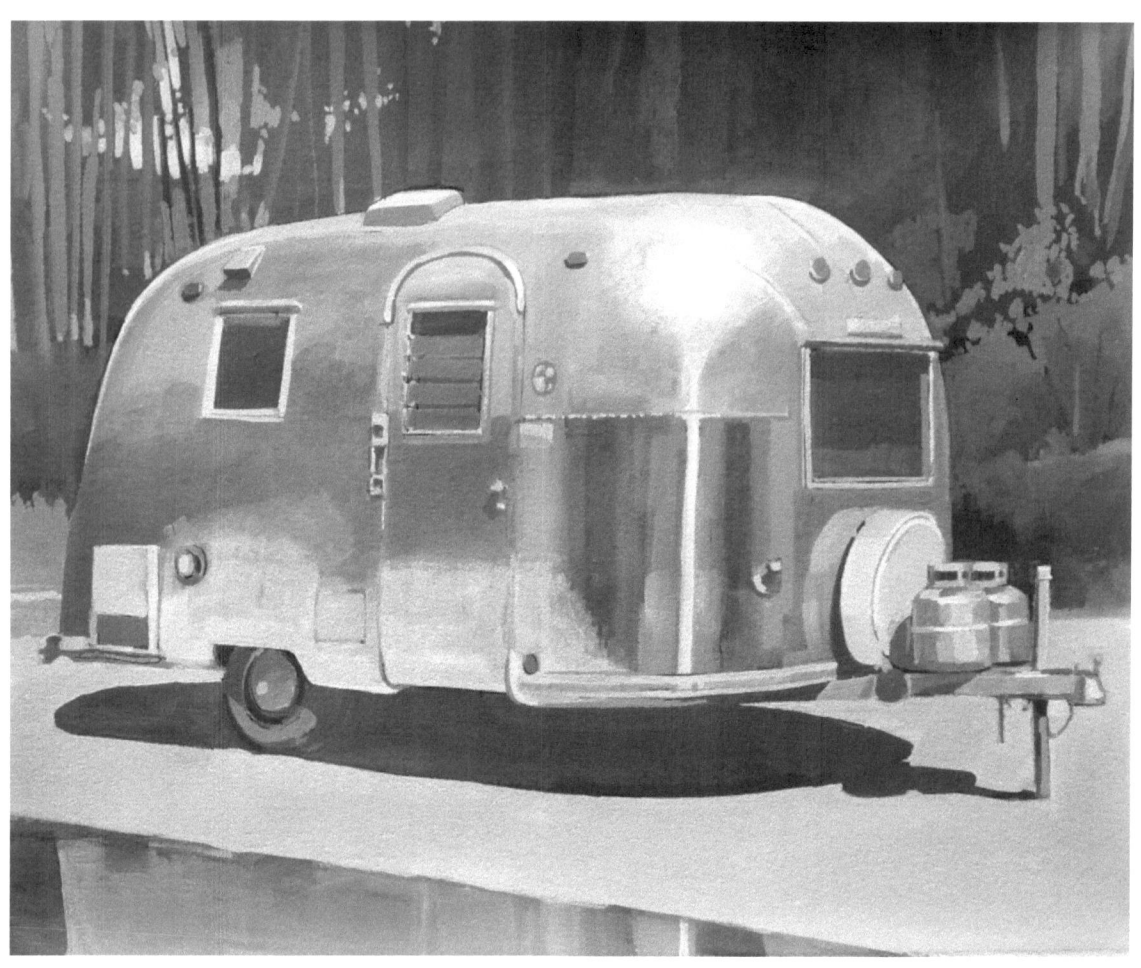

Trailer Envy II: The Airstream

The streamlined, polished Airstream was individually numbered, traveled in packs, and frequented higher class venues than we did.

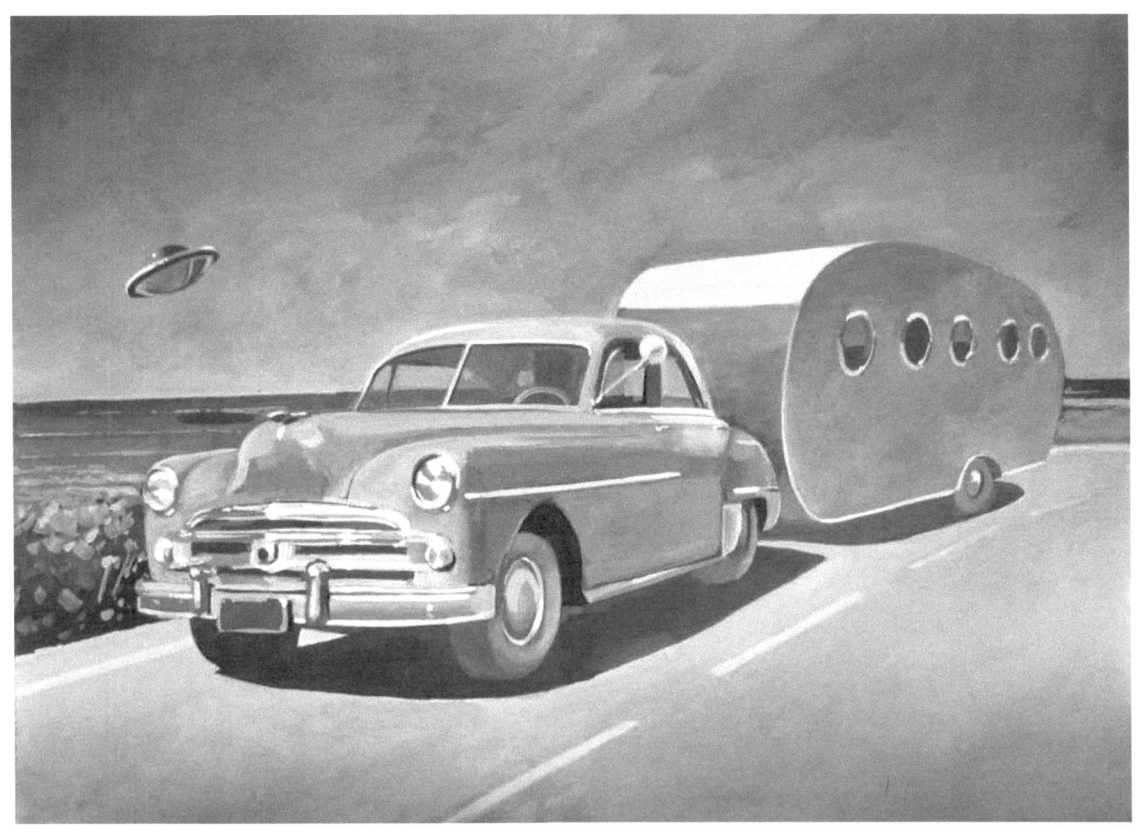

Trailer Envy III: Portholes

Our first trailer had a porthole in the door. The Airfloat Navigator had ten portholes.

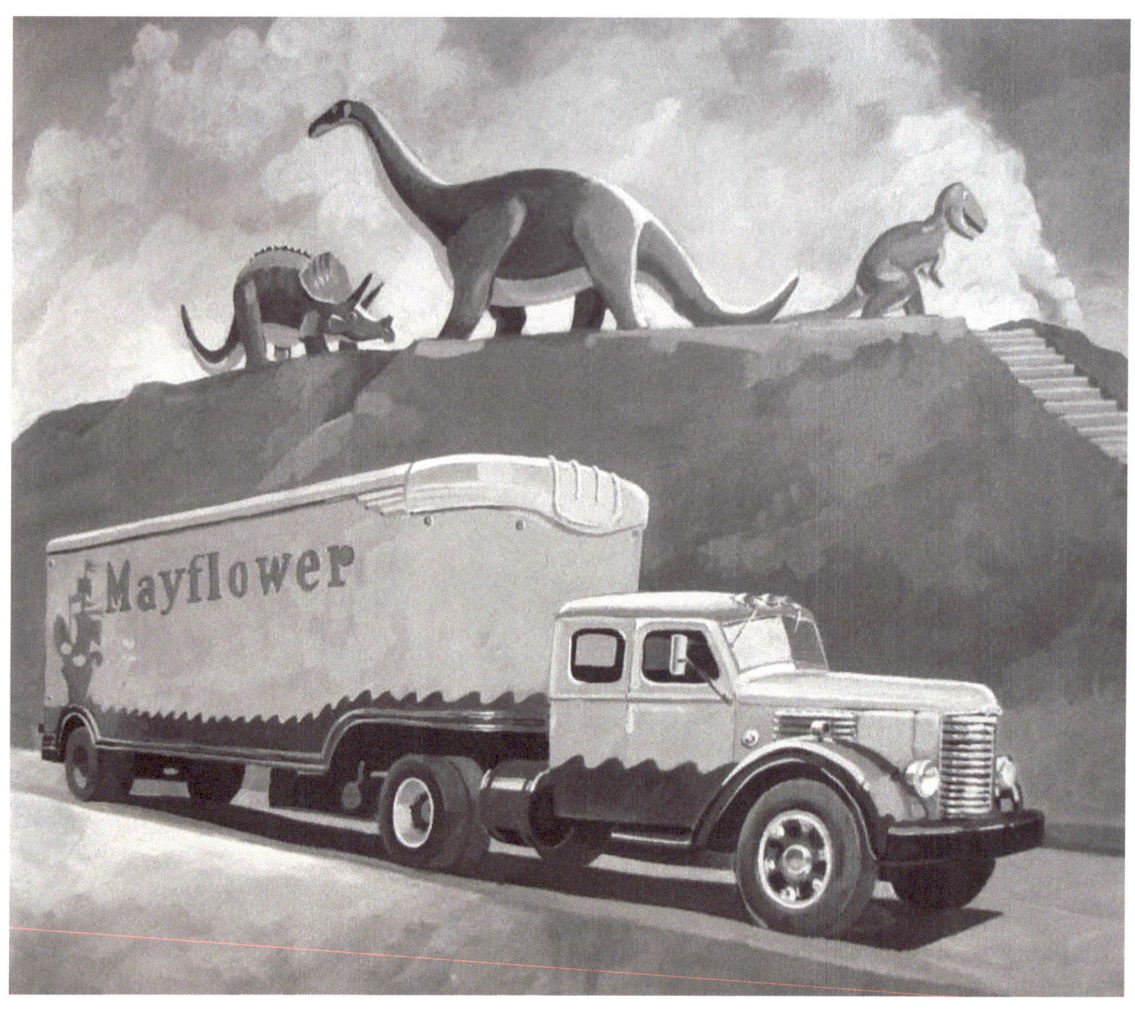

When Dinosaurs Roamed the Earth and 18-wheelers Had 10 Wheels

All of our personal belongings were festooned with Mayflower inventory stickers as a result of our frequent moves.

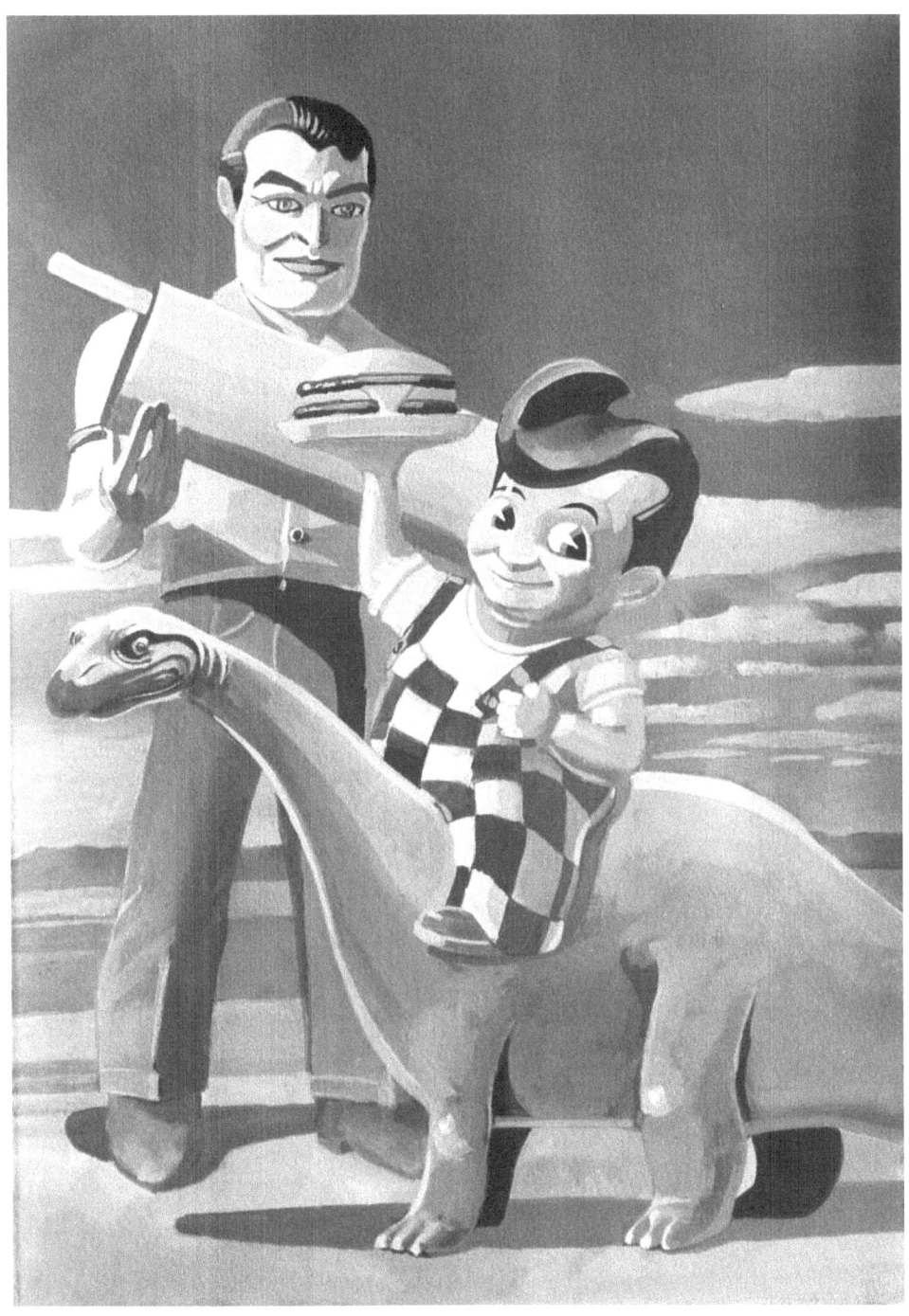

Fiberglass Family: Big Boy and Muffler Man Compare Hairdos

The landscape was strewn with oversized advertising figures.

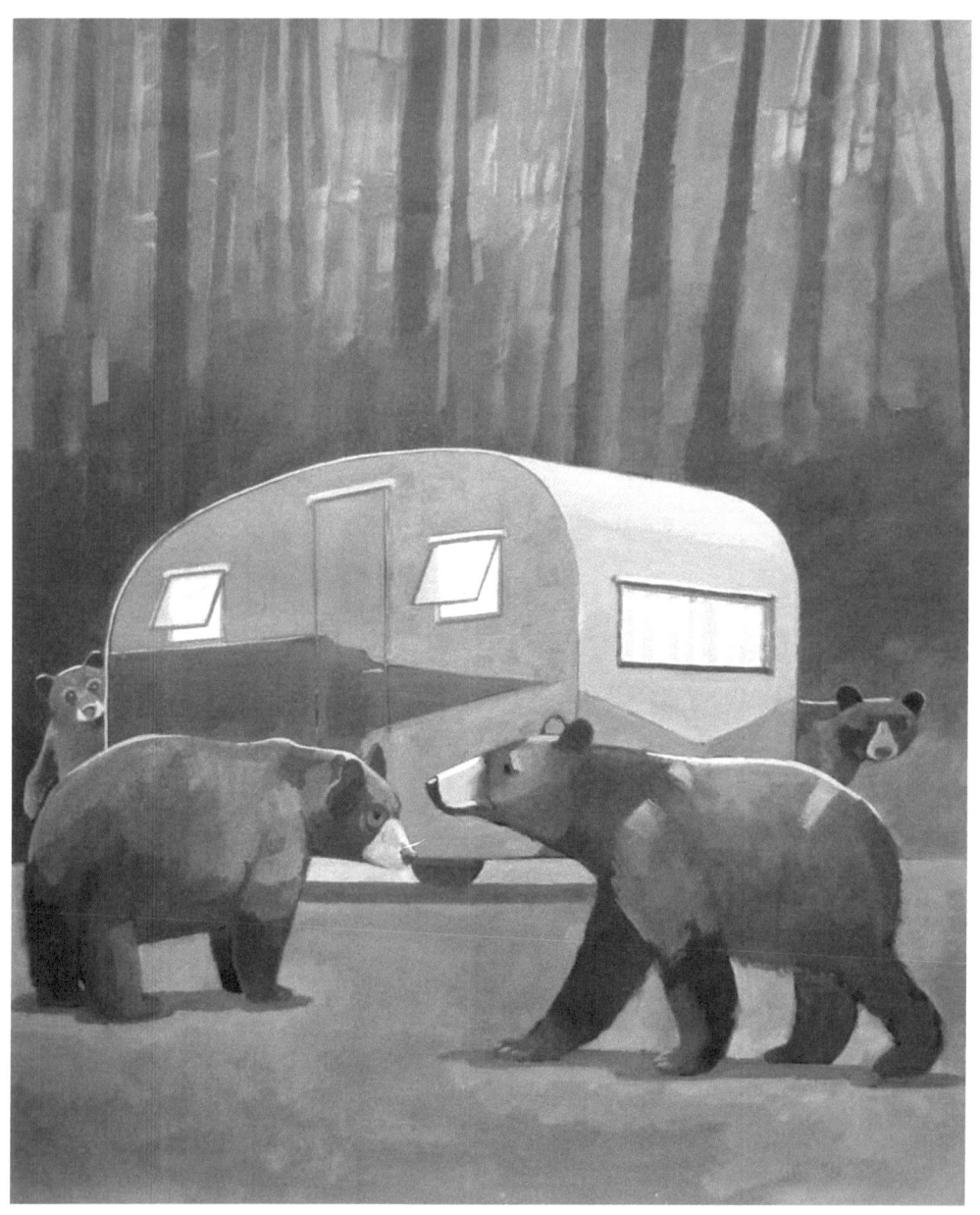

Hold-up

One of the few times our trailer was used in a purely recreational way was a trip to Yellowstone National Park. I was disconcerted by the geographic instability of the place. I was four. My Mother was convinced that the lethargic beggars that held up traffic for free food during the day turned into bloodthirsty marauders at night.

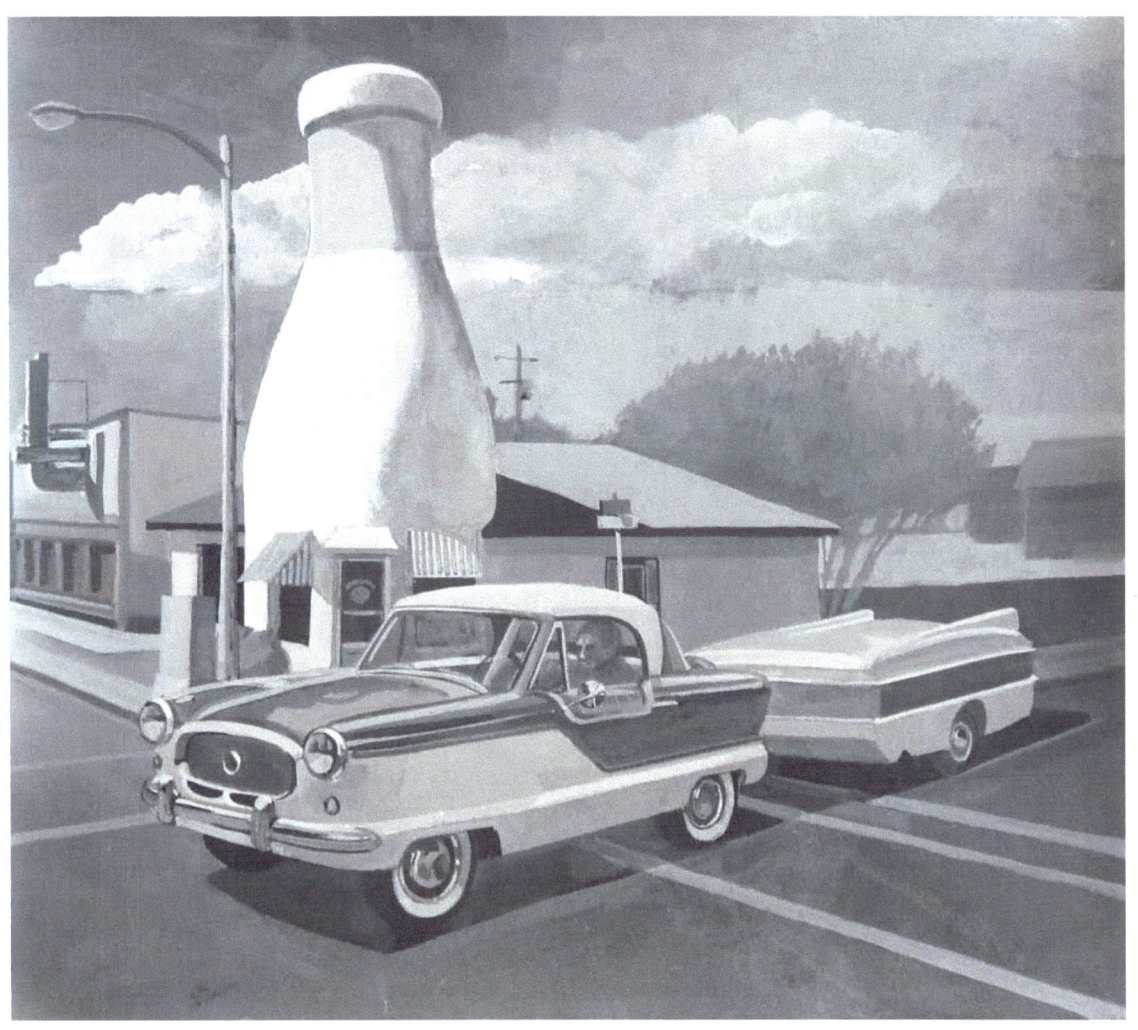

Alternatives II: Pop-up

Pop-up trailers are a lightweight and compact alternative to regular trailers. Fiberglass and canvas, however, do not provide sufficient protection from ravenous bears.

A Nash Metropolitan hauling a pop-up trailer trundles past the Garland Avenue Benewah Creamery in Spokane, Washington.

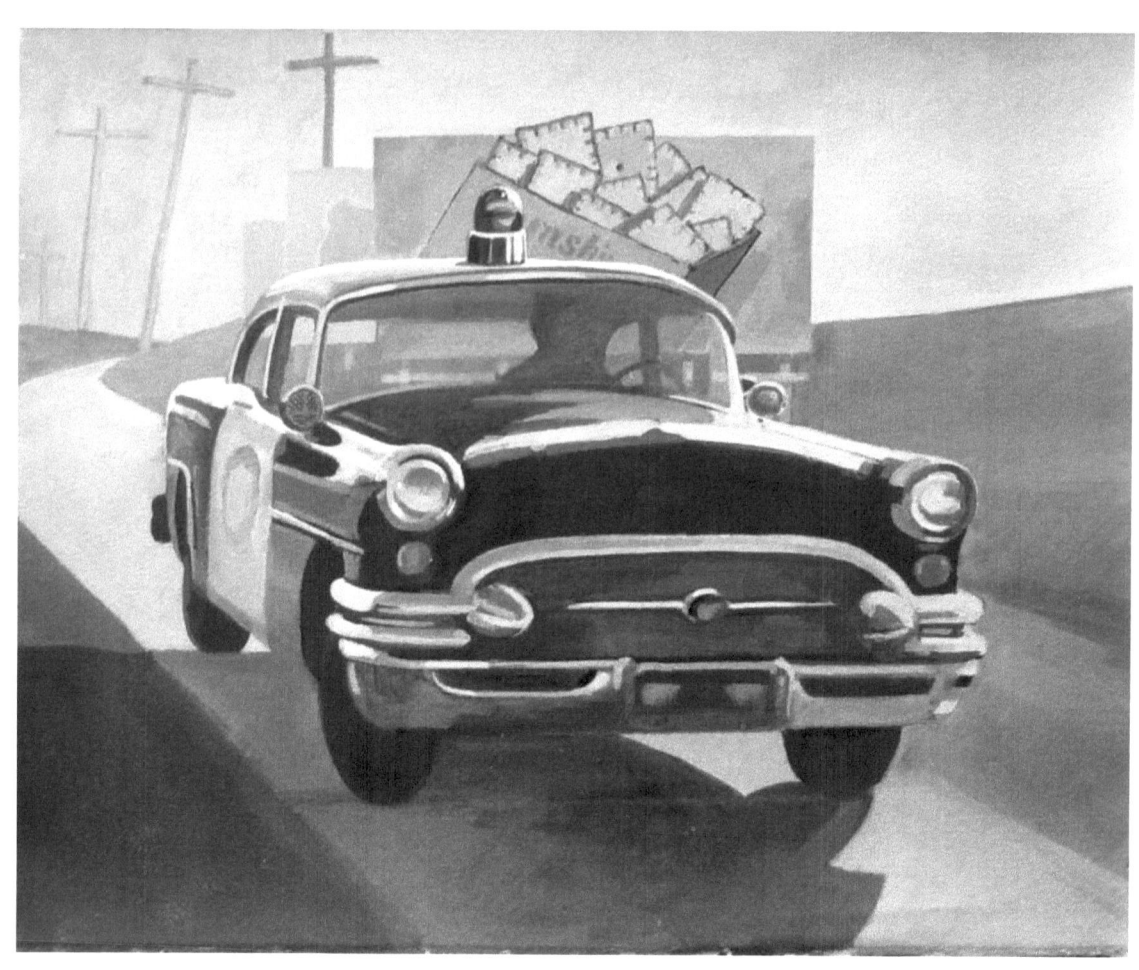

Cheez-it: The Cops.

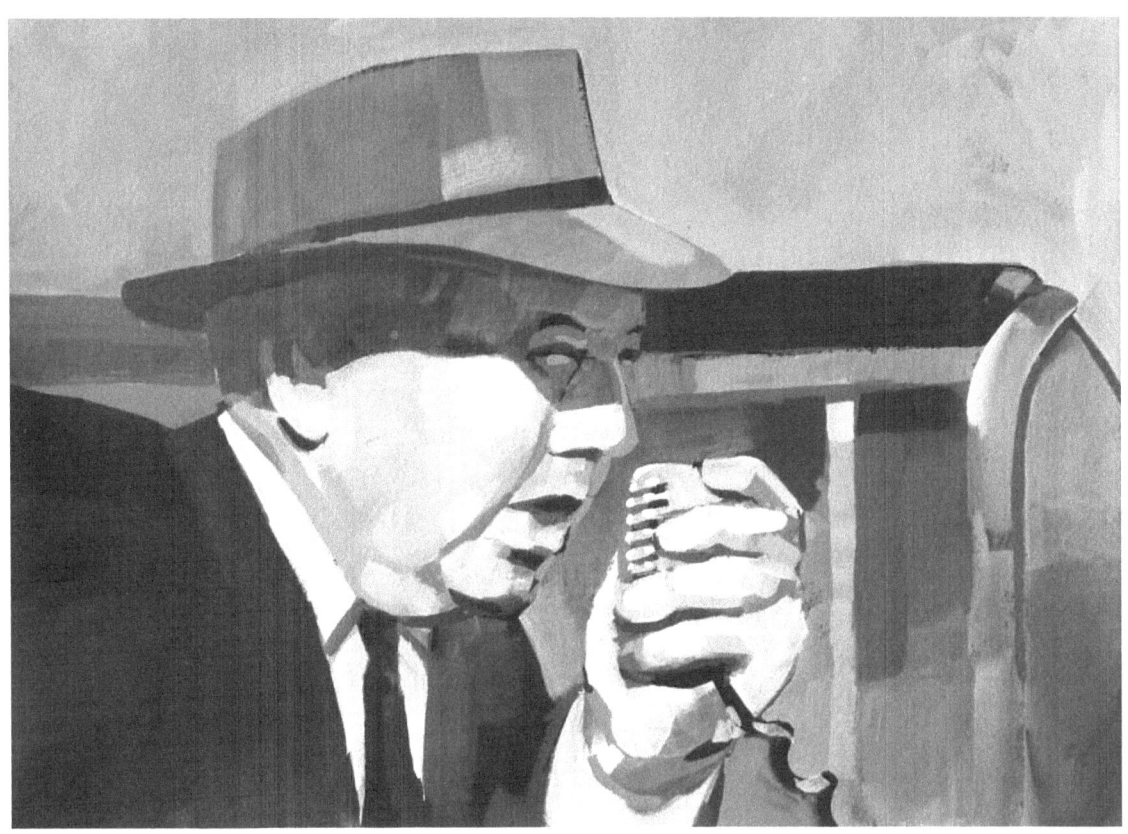

Highway Patrol

In some episodes of Highway Patrol Dan Matthews, played by veteran actor Broderick Crawford, drove a Buick Century just like ours. Sometimes he drove a Dodge or an Oldsmobile but they were always two-door models. In one scene all three occupants exited through the driver-side door.

Crawford, who popularized the use of police 10-codes, managed to make "10-4" mean anything he wanted.

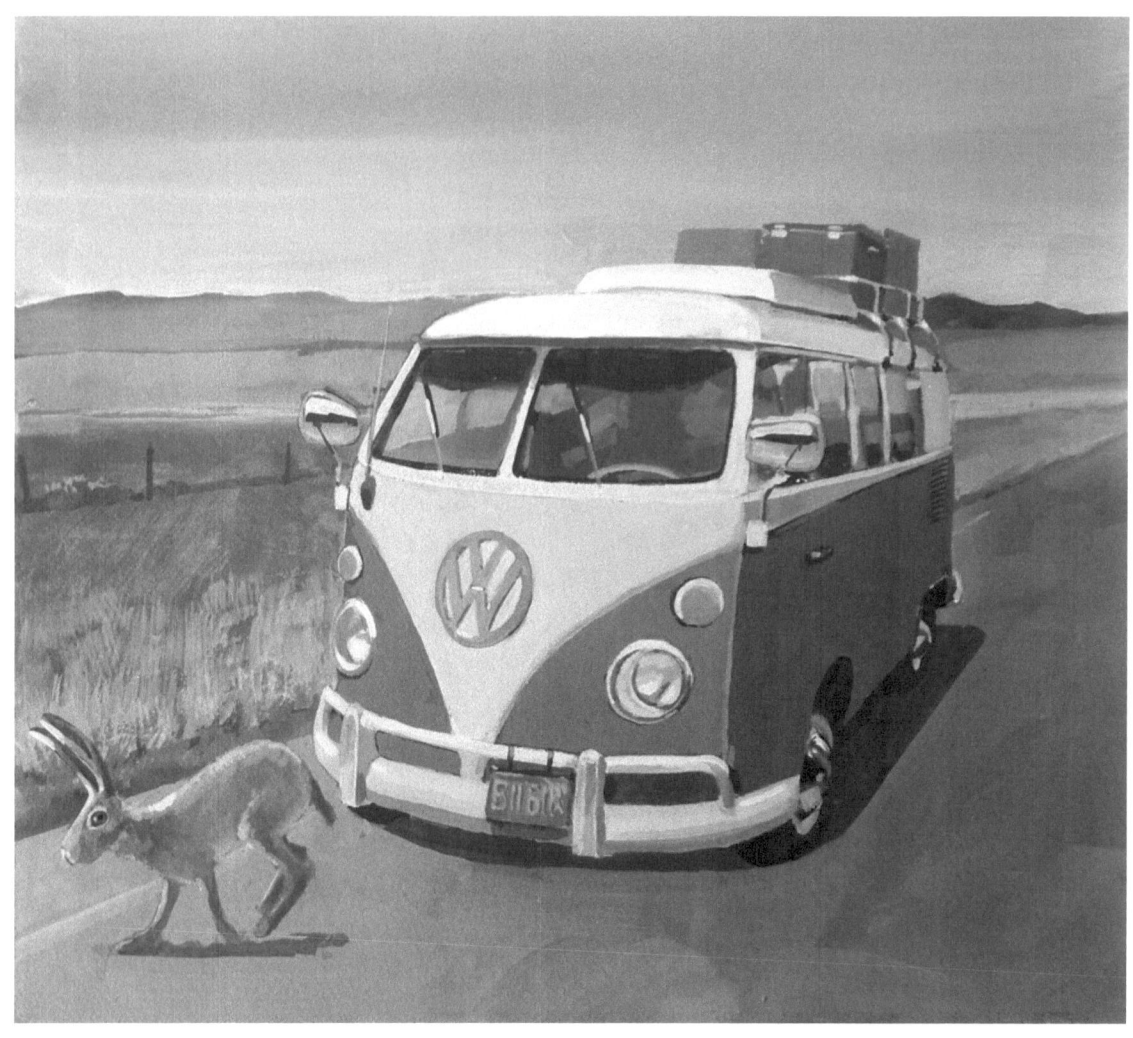

Alternatives III: The VW Camper Bus

Long before being hijacked by hippies the Volkswagen van was preferred by military families who had served in Germany and by actual Germans.

At one time the jackrabbit was seemingly ubiquitous on Western highways. Both the two and three-dimensional varieties dotted the landscape. Drawn to highways by the reflective warmth, green vegetation, and the promise of romantic liaisons, large numbers of the reckless rabbits were sent to the great beyond by speeding cars.

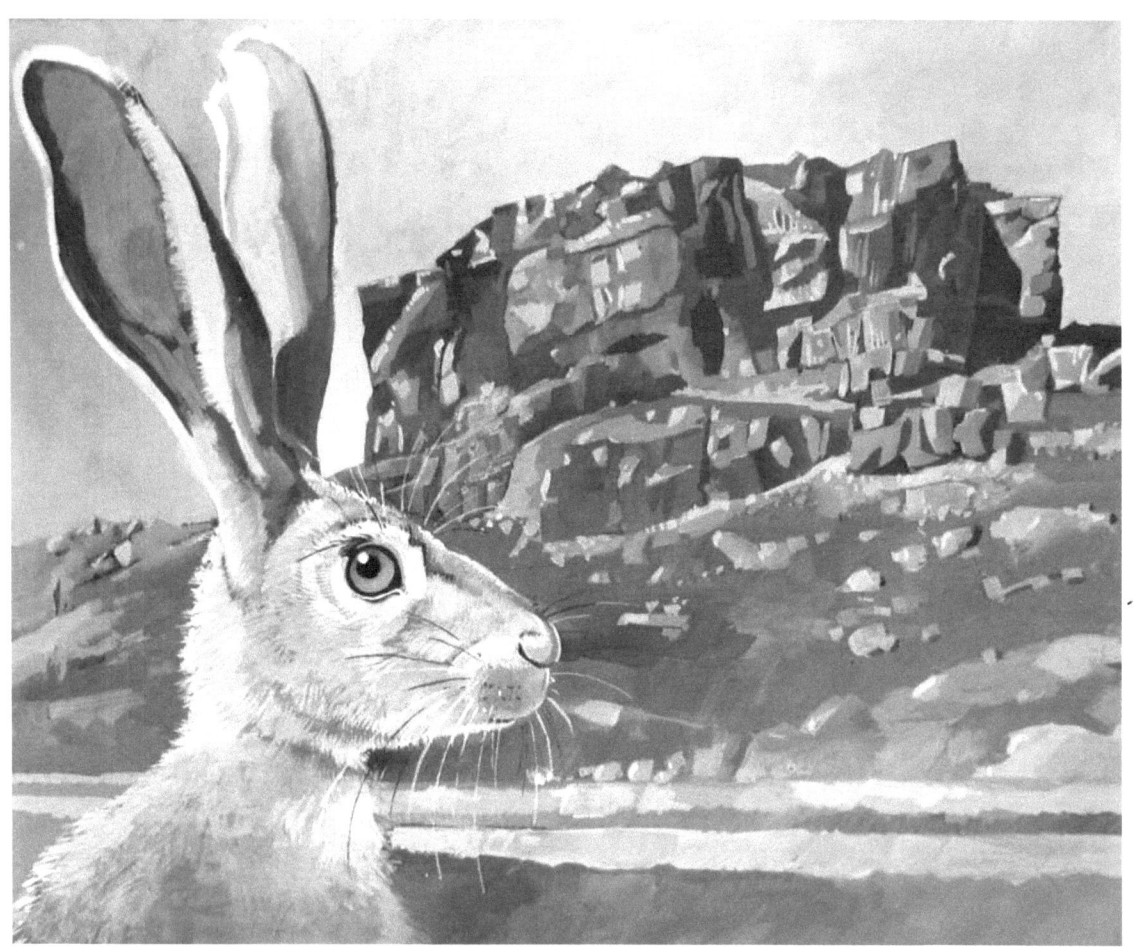

Road Kill: Pompey's Pillar

This jackrabbit is flanked by the Montana sandstone rock formation visited and defaced by Captain William Clark in July, 1806. The outcropping was not named for the Roman general or the brothel-filled city destroyed by Vesuvius but for Jean Baptiste "Pompy" Charbonneau–the infant son of expedition member Sacagawea.

Now a National Monument the landmark was in private hands until the BLM (Bureau of Land Management, not Black Lives Matter) purchased it from the Foote family in 1991. Our visit was in the mid-sixties. The rock was closed for no apparent reason. We ate cold fried chicken outside the gates.

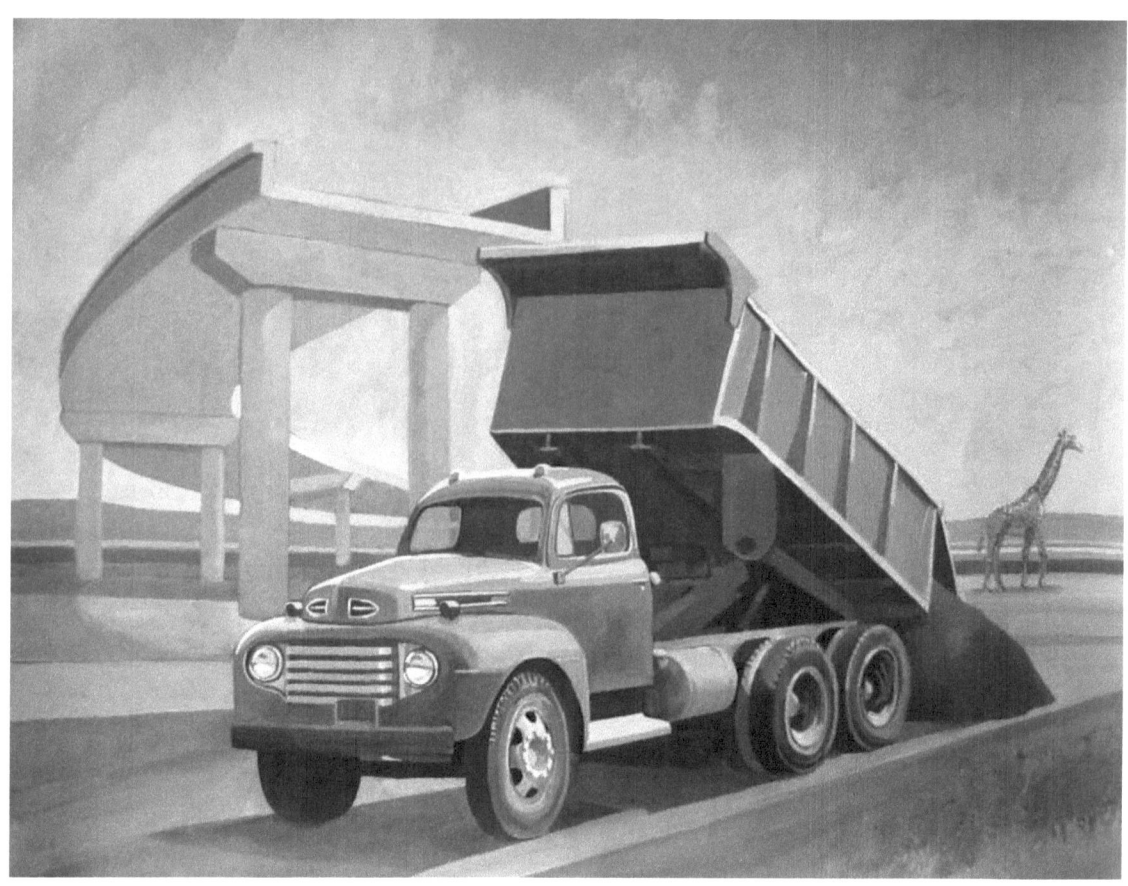

All Traffic Must Exit

Having taken part in the Army's 1919 Transcontinental Motor Convoy which followed the Lincoln Highway from Washington, DC to San Francisco and later being exposed to the superior German Autobahn, President Eisenhower saw the need for a Federal Highway System that would link American Air Force Bases. He had also learned that claiming national defense as a purpose for any project helped loosen purse strings.

As the Dwight D. Eisenhower National System of Interstate and Defense Highways was being constructed, and sometimes for years afterward, your stretch of the newborn road would abruptly end and you would find yourself back on an undivided two-lane in Wolf Lodge or Ritzville or Tremonton.

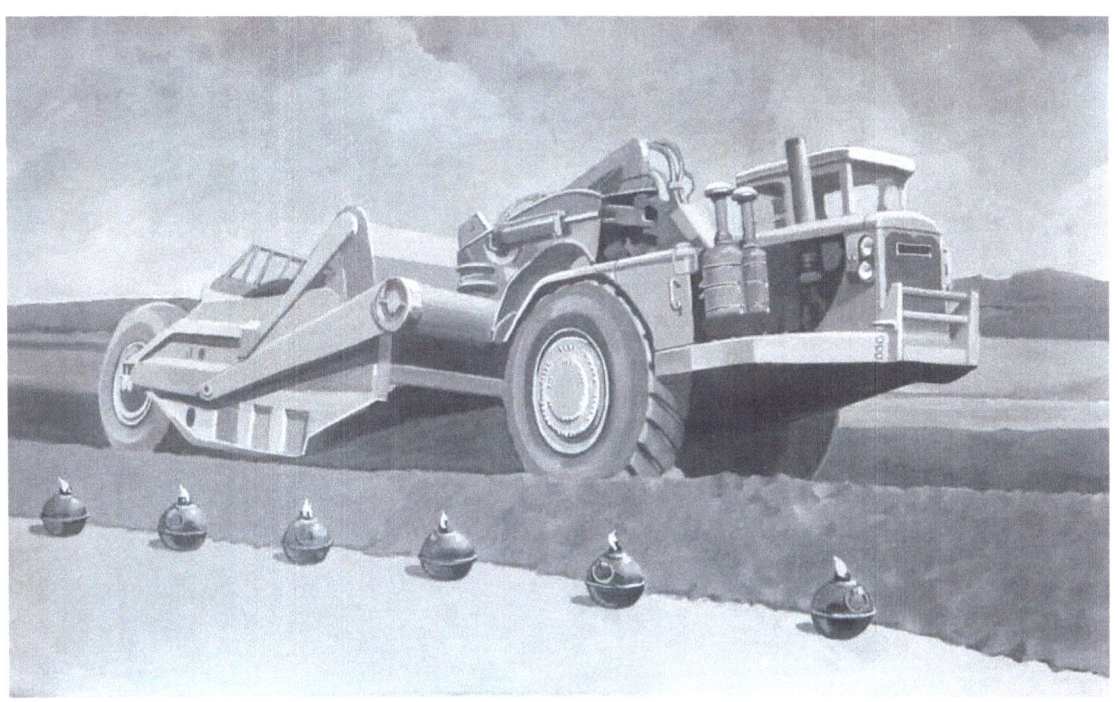

Belly Scraper With Smudge Pots

Belly scrapers lumbered across the Montana landscape like huge bugs.

Road construction was often indicated by rows of flaming smudge pots that looked suspiciously like cartoon bombs.

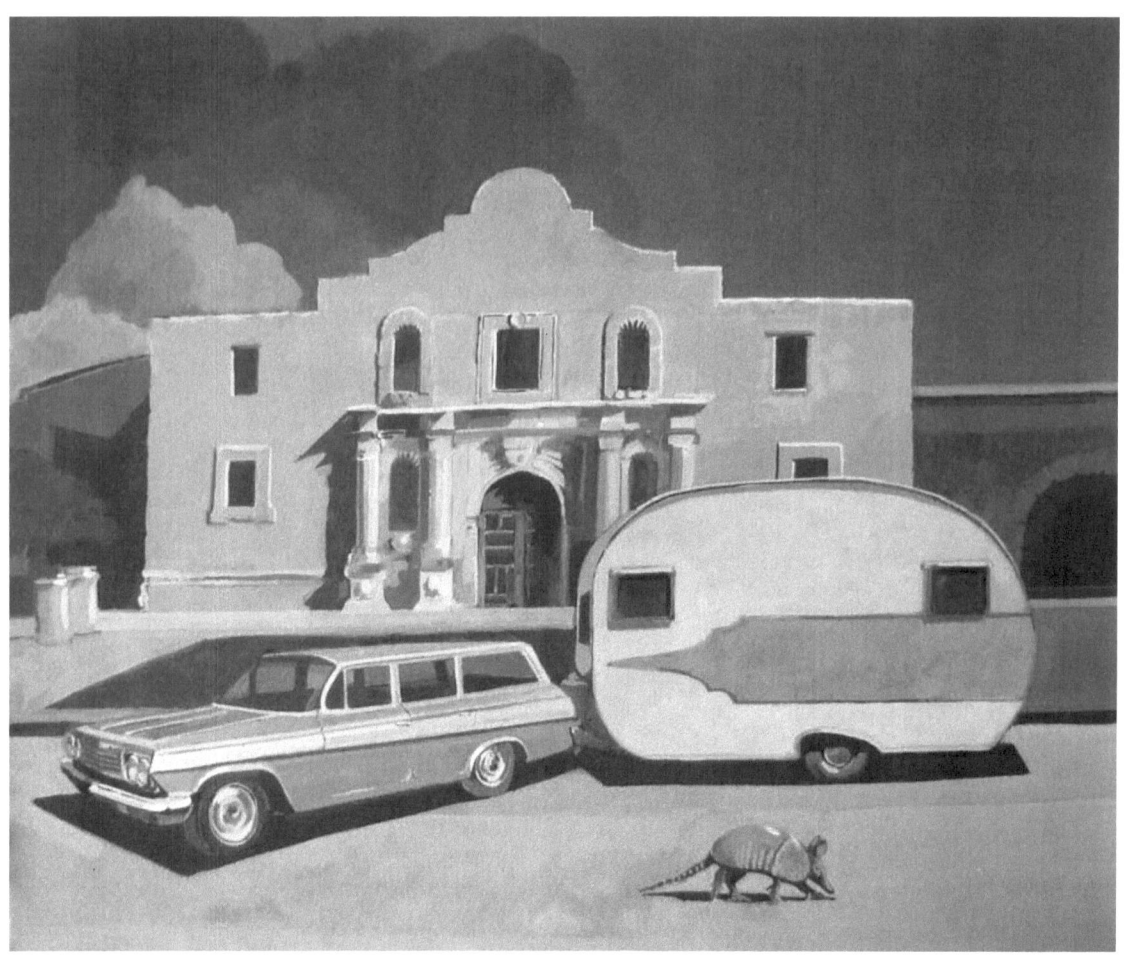

Remember?

A diehard Buick man, Dad gave into the realities of five children and a dog and bought a Chevy Bel Air station wagon just before moving to Texas. It had a rear facing third-row bench seat which made everyone carsick. We usually just laid it flat and rolled around in the back. The car lost a hubcap driving home from the dealer and it was all downhill from there.

"A Chevy is a car, but a Buick is an automobile."

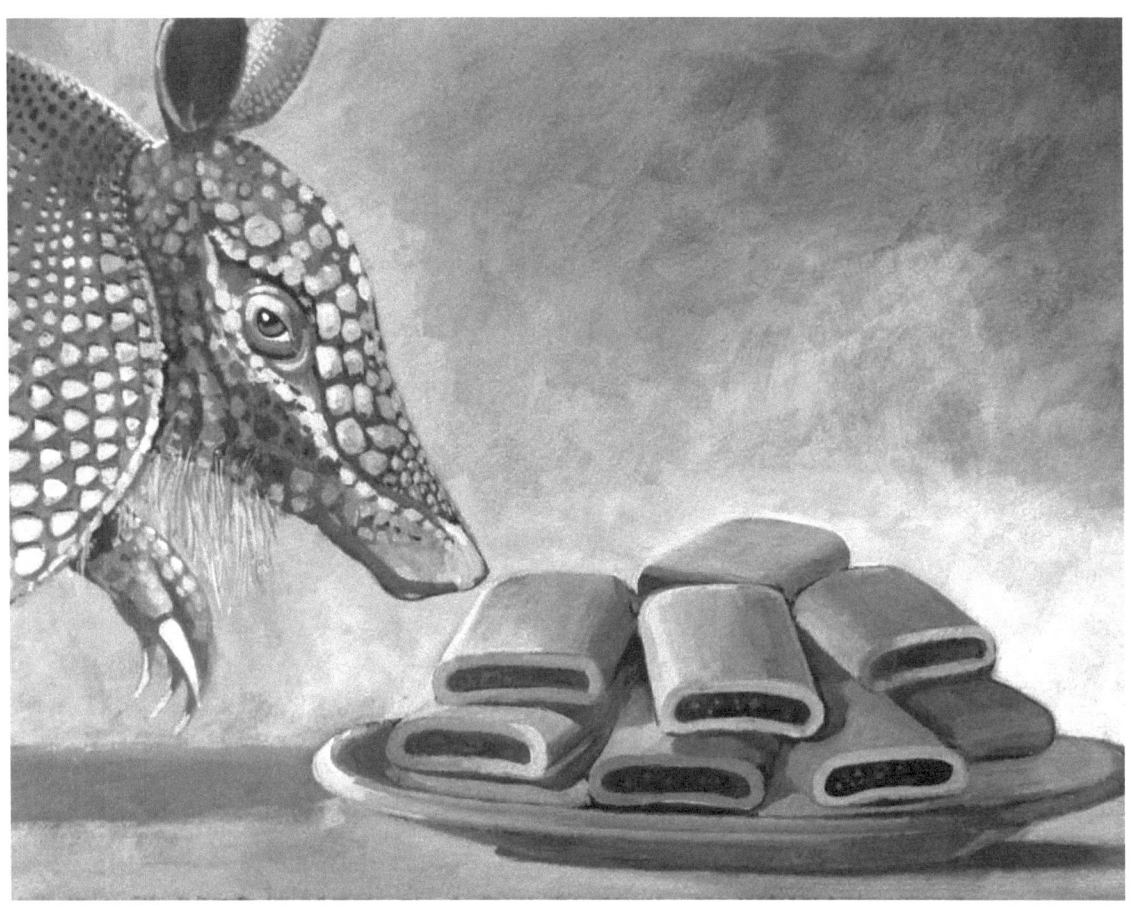

Road Kill and Road Food

Mom would fry chicken the night before a trip and we would eat it cold on the road. If we were in the right geographic region we would get an A&P Spanish Bar. If not, a homemade "hard time" cake (so called because the recipe didn't call for eggs) would do. She would usually bring a package of Fig Newtons because she was the only one who would eat the gritty, sad-faced abominations.

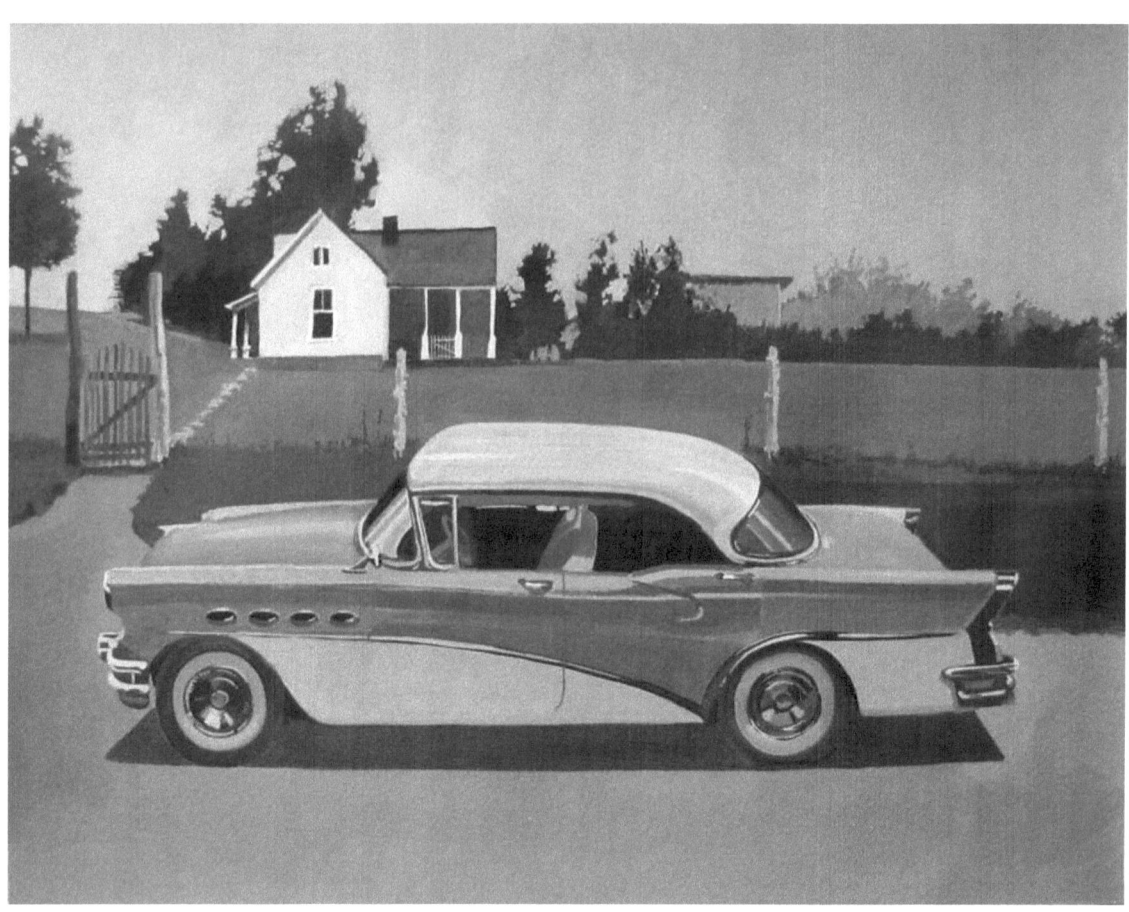

Over the River

We usually won the silver dollar for traveling the farthest to family reunions. We parked the trailer in Kentucky with a Roberson and then crossed the Ohio River into Indiana to visit some Reasors. For me it was like visiting a foreign country with different customs, religion, and language. It was an exotic and humid land of porch swings and lightening bugs.

This is the farm my Dad grew up on. By the time I came along my widowed Grandmother had moved into town. She had a woodpecker door knocker, yellow water, and a single die cast John Deere toy tractor to play with.

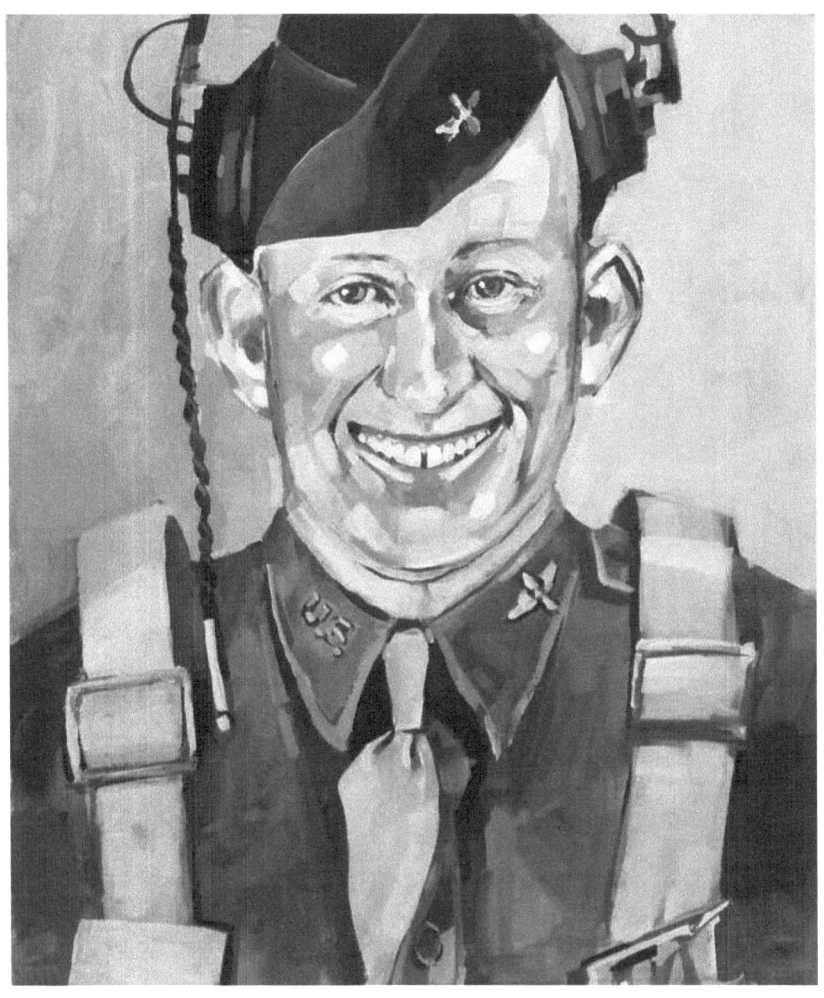

The Navigator

In 1940, with war on the horizon, Dad and his twin brother enlisted. They traded their lives as Indiana farm boys to become officers and gentlemen. Dad became a navigator and was assigned to the Ferry Command where he flew sled dogs to the Battle of the Bulge. His brother became a pilot and bombed Montecassino.

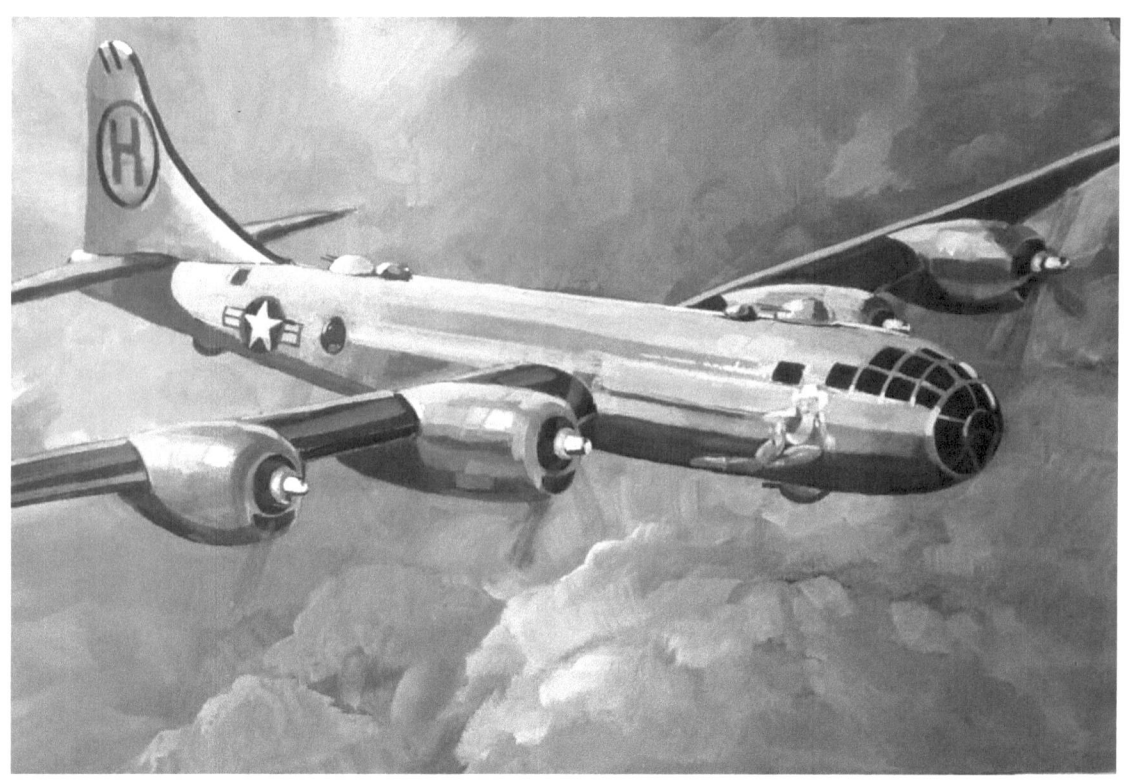

Police Action: Celestial Navigation

In his military history Dad said,

"I had navigated to London, Paris and Calcutta; to South America, Europe, Africa and Asia; to the islands of the Atlantic from Greenland to Ascension Island. I had navigated to Hawaii, Philippines, Okinawa, Japan and the islands in between.

I can't number the times I looked out the window after flying many hours over the ocean, with nothing but celestial bodies to fix my position, to see a tiny speck of land that I expected to see, when I expected to see it. That tiny speck was usually covered with clouds and invisible until a few miles away."

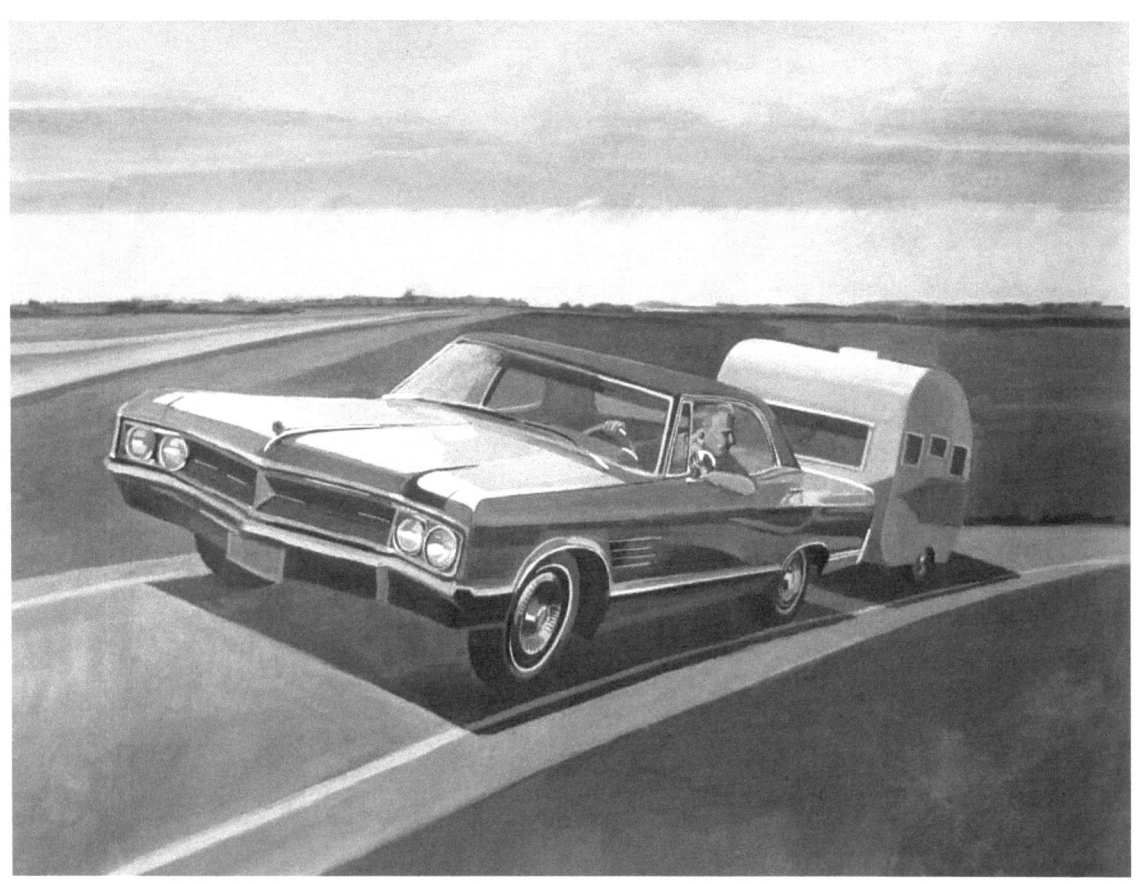

Give Up, Surrender, Back Down

On the other hand, terrestrial navigation of the new Interstate Highways often proved to be more of a challenge. More than once he found himself backing down an off-ramp he had driven up in error.

As he neared retirement from the Air Force Dad left behind his years in the Chevy wilderness and treated himself to a brand new 1965 Buick Wildcat. It was a sweet ride. He probably thought he was going to be earning enough selling mutual funds to make the payments. Think again.

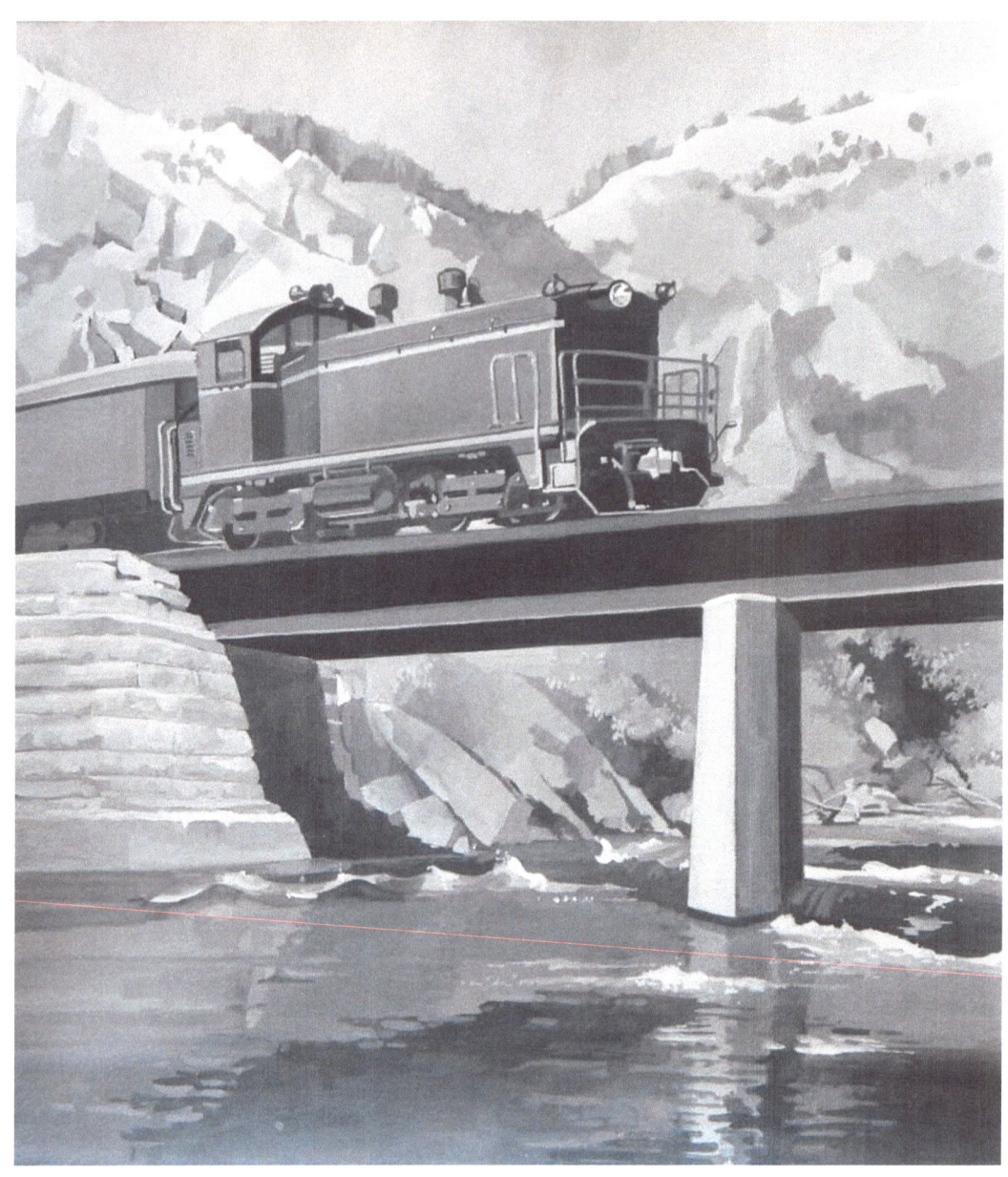

Over a Different River

On two occasions we parked the trailer at Canyon Glen in Provo Canyon while waiting for real houses. There was a bridge that teenagers jumped off of, my mother fished from, and a train regularly crossed. I was in a state of great anxiety while my mother fished. There were no showers but there was a small trading post that sold Necco wafers and rubber erasers (the erasers tasted better).

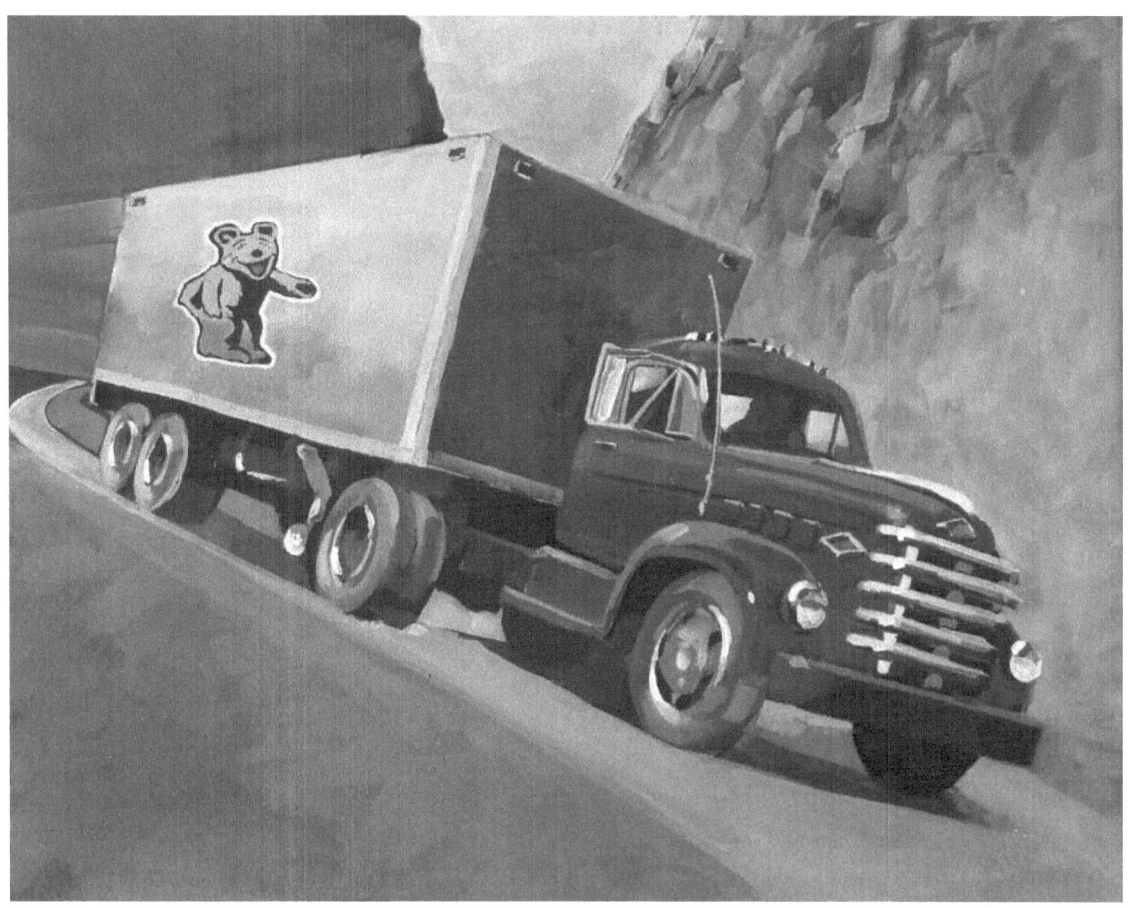

Jake Brakes

The constant sounds of rushing water, the breeze blowing through the trees, and trucks using their Jake Brakes as they descended the canyon were the soundtrack to life in the Glen.

Jacobs Engine Brakes alter the operation of the engine's exhaust valves providing a retarding action to the vehicle's drive wheels, enabling improved vehicle control without using the service brakes. This conservation results in reduced service brake maintenance, shorter trip times, and lower total cost of ownership.

This conservation also results in the thunderous BOOGADUH-BOOGADUH-BOOGADUH that echoed off the canyon walls.

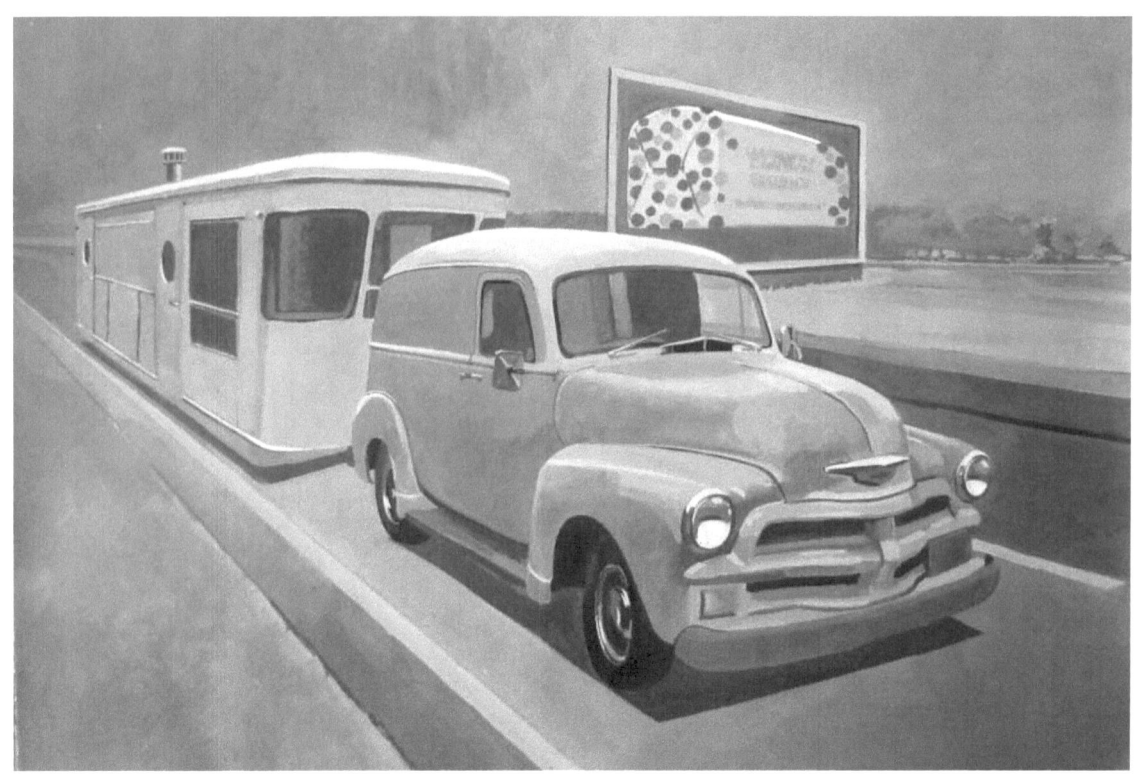

Trailer Envy IV: Bathroom, Backdoor & Bedroom

Our trailer was not self-contained. We used gas station bathrooms, trailer park shower rooms and the occasional bush. At night Mom placed an open half-gallon cardboard milk carton in the middle of the floor for emergency use.

As an Air Force family we bought a month's worth of milk (in cardboard cartons) and Wonder Bread from the commissary. The only time I had bread that hadn't been in the freezer was in the car on the trip home from the base.

After World War II, J. Paul Getty converted his Spartan Aircraft Company to trailer manufacturing. The Spartan Imperial Manor was large, semi-permanent, and out of our league.

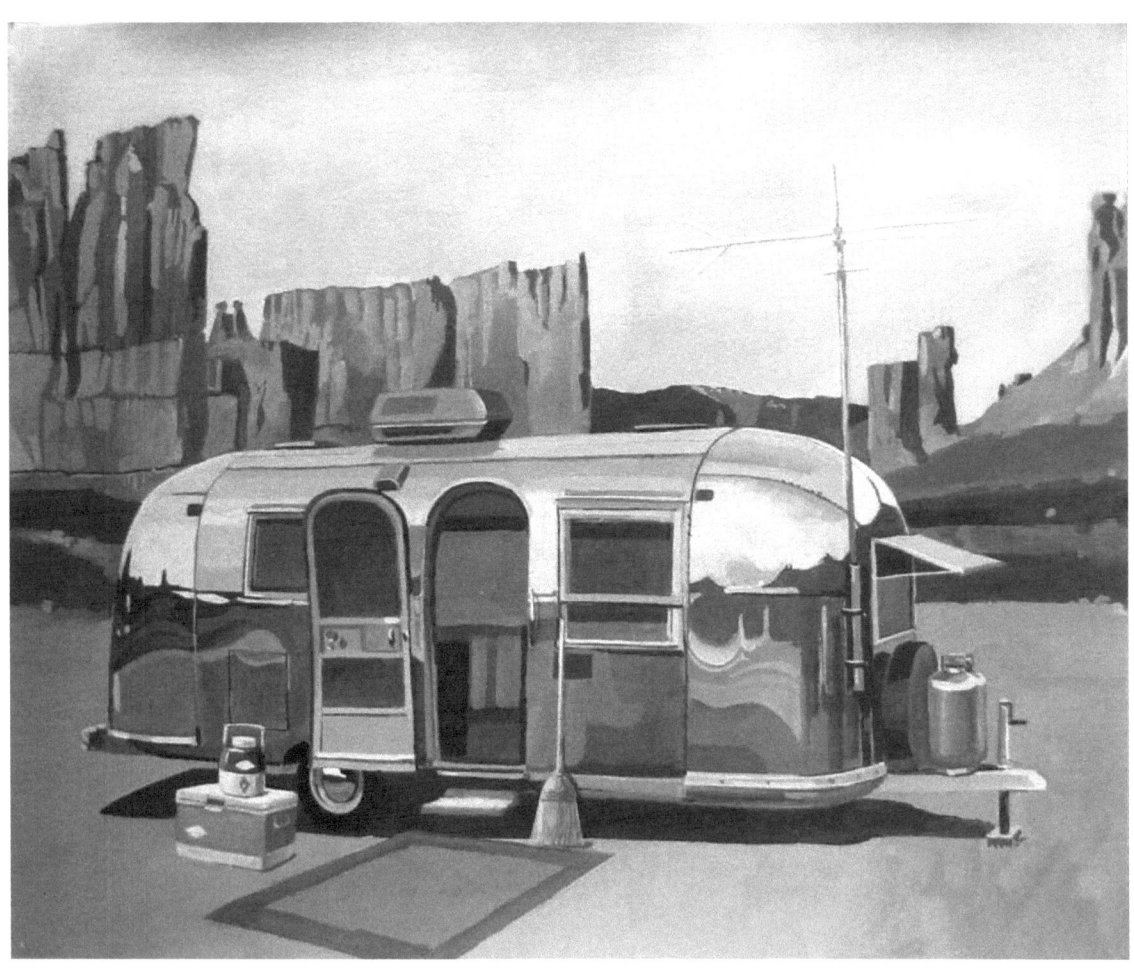

Trailer Envy V: AC & TV

We didn't have a fan, let alone air conditioning. Television was out of the question. We did have a pink Coleman cooler and a broom.

After we moved to Spokane, Dad would sometimes drag the trailer up to Van Dissel's Waitts Lake Resort. Mom and Dad would head out fishing before the sun was up and for breakfast Mom would fry up a mess of fresh rainbow trout dredged in cornmeal.

In August of 1967 we missed the final episode of *The Fugitive* (a Quinn Martin production) because we were at Waits Lake. One of the nearby trailers had a TV. I learned the meaning of the word covet.

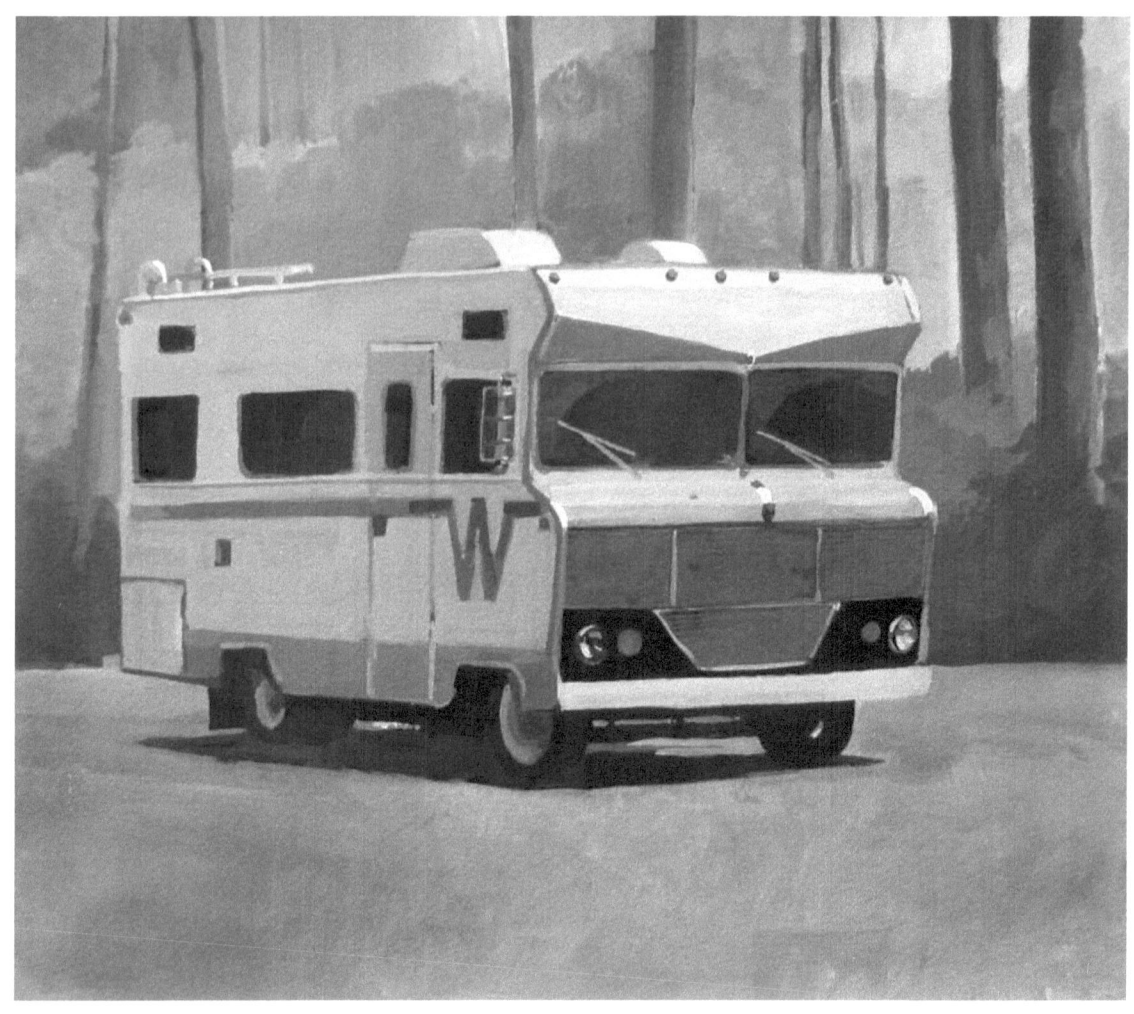

Alternatives IV : The Winnebago

Not every facial tissue is a Kleenex. Not every ice resurfacing machine is a Zamboni. Not every motor home is a Winnebago but that's what we called them all.

Sightings

In Dad's post-military career his duties as a vocational rehabilitation counselor included occasional visits to remote locations in Northern Washington.

On one trip he parked the trailer on the Columbia River while he made his rounds. One afternoon while out scouting for Sasquatch tracks I saw an enormous aquatic creature breach the still waters of the river. People said it might have been a giant sturgeon, but I know better.

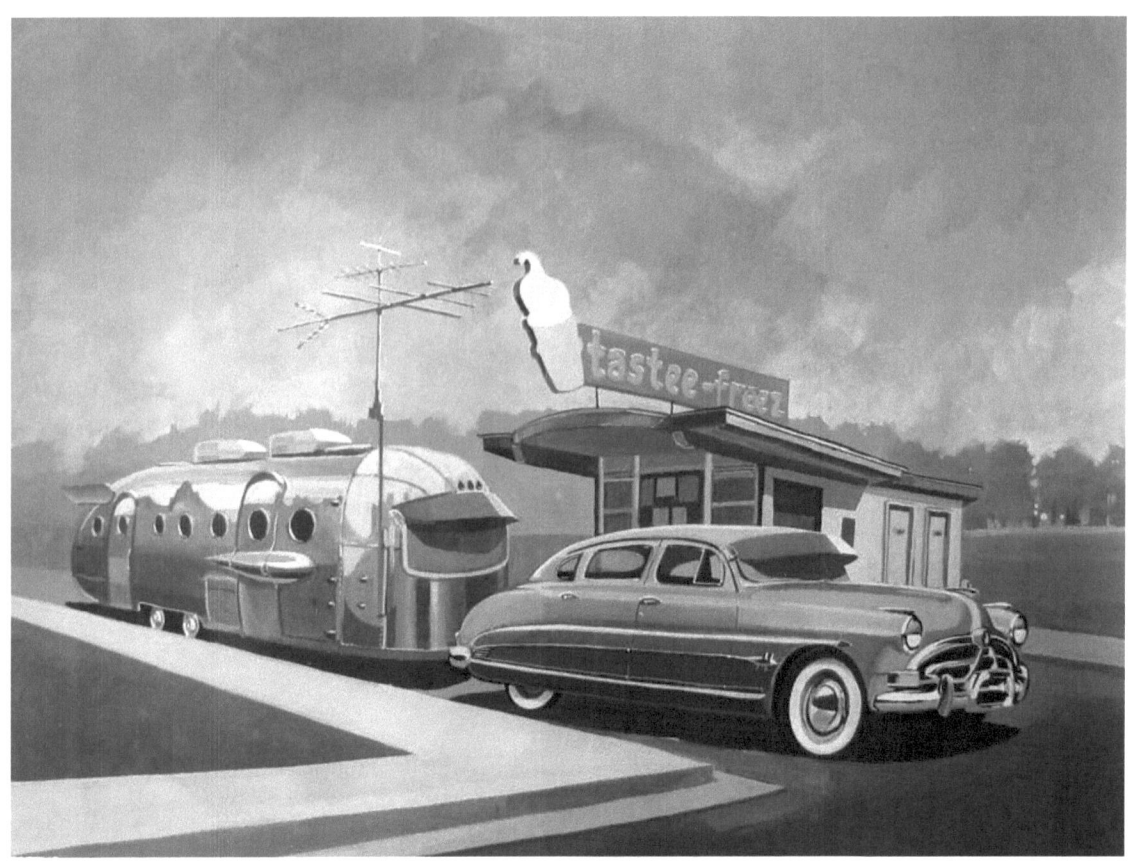

The Ideal

My ideal trailer would be aerodynamic polished aluminum with a backdoor, bathroom, bedroom, dual air conditioners, portholes, tail fins, vestigial wing buds, superfluous teardrop running lights, Color TV, and a visor all pulled by a sleek Hudson Hornet.

Pre-interstate Highway travel required that you slow down and drive through towns. You got to see their Main Street Christmas decorations, their city park, and their hardware store. Restaurants and motels were located in town rather than clustered around interchanges.

We were towing a kitchen. We never stopped at restaurants.

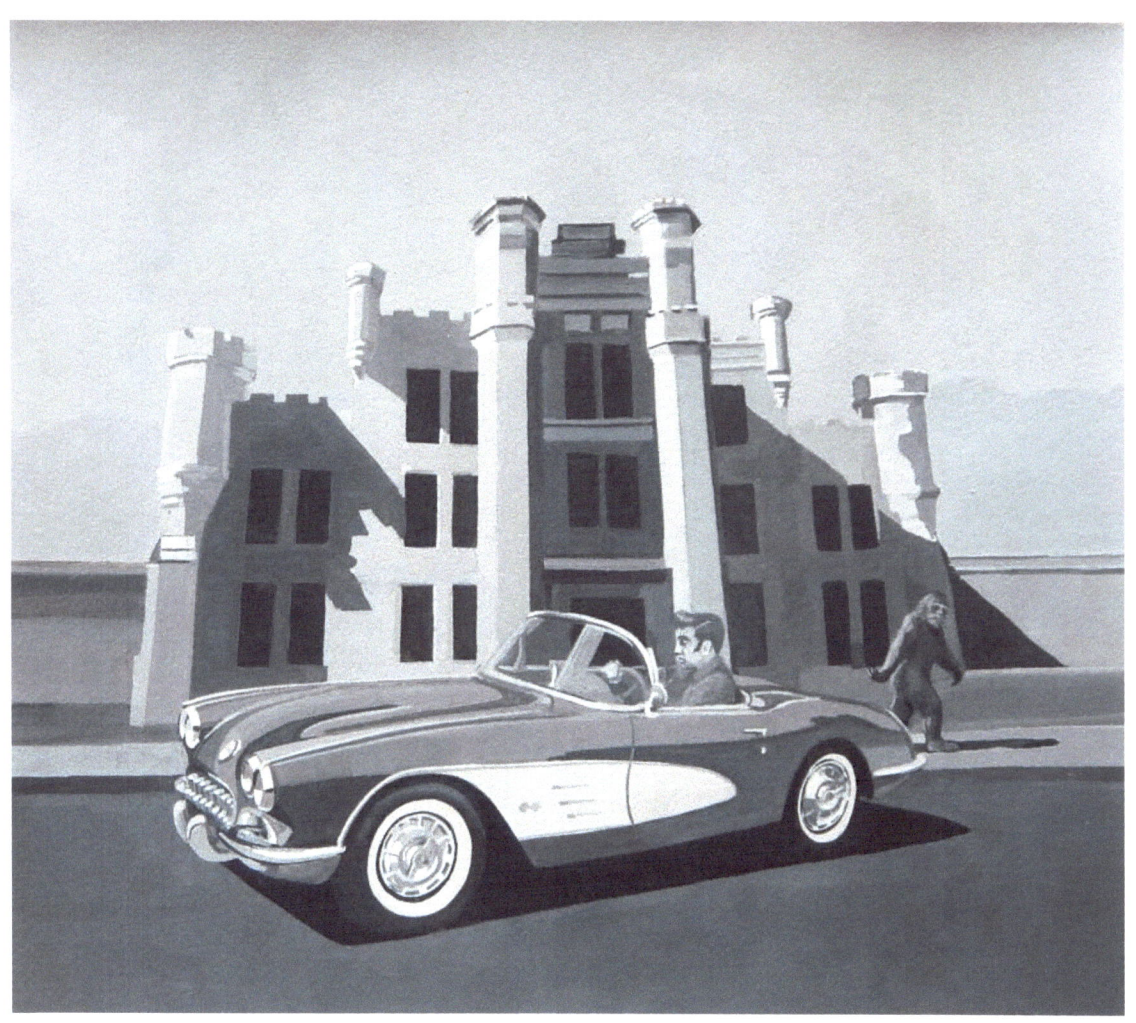

Get Your Kicks: Corvette at Joliet

The most famous pre-interstate highways were Route 66 and the Lincoln Highway. They were neither romantic nor nostalgic when we drove on them. They were simply the line (not straight) between two points. I have two clear recollections of traveling on Route 66. The first involved trying to sound out the word ALBUQUERQUE with amusing results. The second was riding shotgun trying to keep my father awake. I was listening to Wolfman Jack on the radio. We pulled into a truck stop and I got a bottle of root beer. Root beer tastes really weird at 2 am.

Joliet, Illinois is the point where Route 66 and the Lincoln Highway briefly converge.

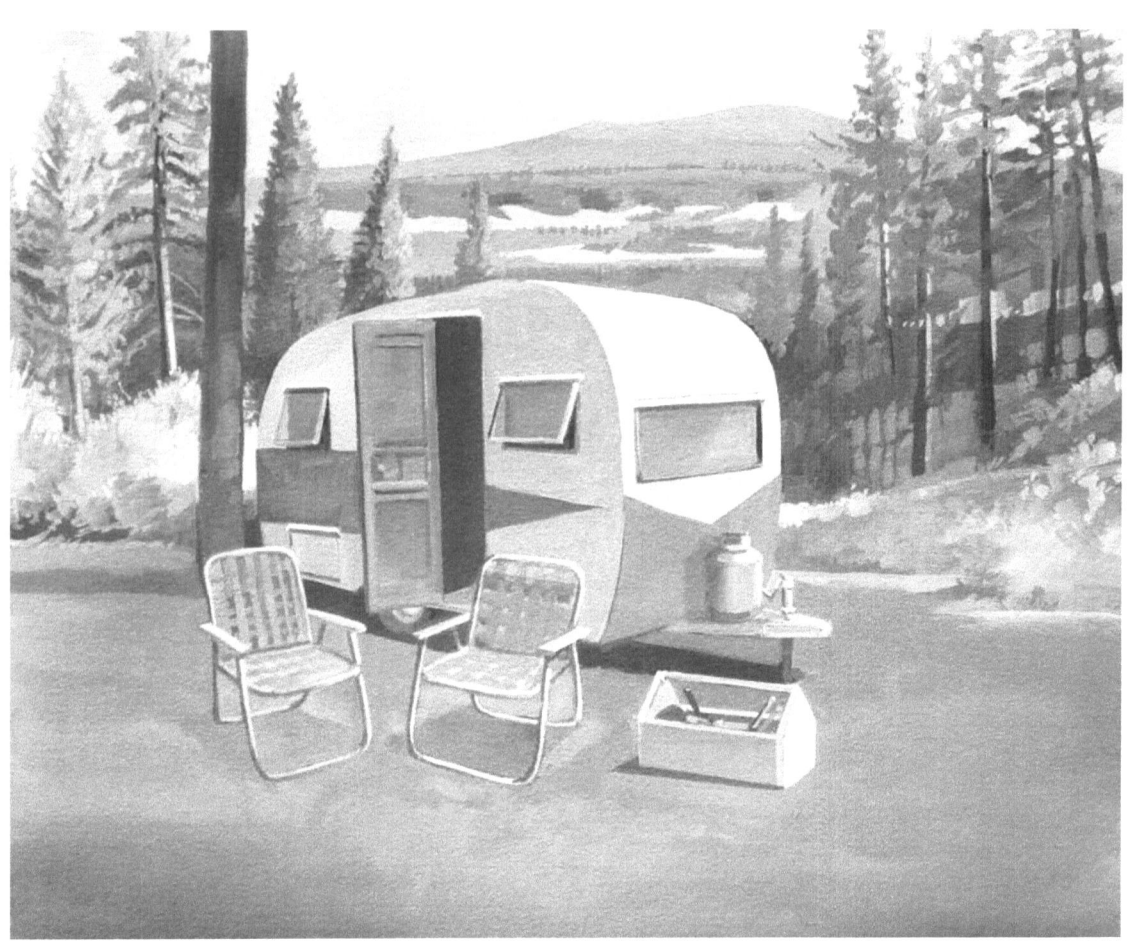

The End

My first Summer back from college we lived on-site in the trailer while my parents built their dream home. After the house was finished the trailer sat mostly unused in the yard until the day a young couple in a Jeep Wagoneer dragged it away in a cloud of Dunn Road dust. They claimed it was just what they were looking for.

www.ingramcontent.com/pod-product-compliance
Lightning Source LLC
Chambersburg PA
CBHW051105180526
45172CB00002B/778